Z00

In HARMONY with NATURE

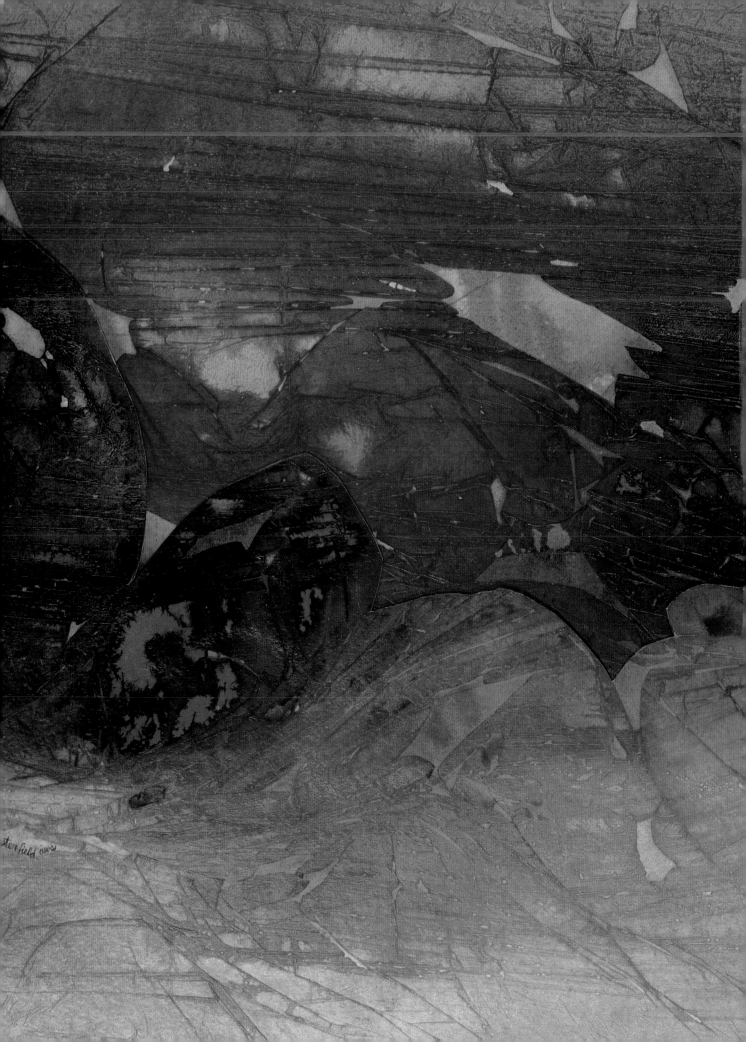

In HARMONY with NATURE

Maxine Masterfield

Watson-Guptill Publications/New York

To George

Art on title page:
MID AUTUMN, Maxine Masterfield. *32" x 60" (81cm x 152cm), inks on Morilla board. Private collection.*

Copyright © 1990 Maxine Masterfield

First published in 1990 in the United States by Watson-Guptill Publications, a division of BPI Communications, Inc., 1515 Broadway, New York, N.Y. 10036.

Library of Congress Cataloging-in-Publication Data

Masterfield, Maxine.
 In harmony with nature : painting techniques for a new age /
Maxine Masterfield.
 p. cm.
 Includes index.
 ISBN 0-8230-3641-3
 1. Art—Technique. 2. Visual perception. 3. Texture (Art)
I. Title.
N7430.M32 1990 90-36554
702'.8—dc20 CIP

Distributed in the United Kingdom by Phaidon Press Ltd.,
Musterlin House, Jordan Hill Road, Oxford OX2 8DP.

Distributed in Europe, the Far East, Southeast and Central Asia, and South
America by RotoVision S.A., 9 Route Suisse, CH-1295 Mies, Switzerland.

Manufactured in Malaysia

First printing, 1990

3 4 5 6 7 8 9 10/94 93

Edited by Janet Frick
Text set in ITC Gallia

Contents

Introduction

WIND, WATER, SUN AND SAND, Maxine Masterfield. *46" x 44"*
(117 cm x 112 cm), inks on Morilla 140 lb. paper. Courtesy of Kanes Furniture, Sarasota,
Florida.

This study of wind and water patterns was created using the sand
technique discussed on pages 28–45.

Art and nature have been inseparable since the first artist. Artists create, just as nature creates—but we do it on a much smaller scale. We try to portray on a limited surface in a short period of time what is unlimited in scope and has developed over aeons. We are inspired by nature's beauty, but we find it so intricate that we can never really grasp all its details, no matter how hard or long we study them. We can merely produce an illusion of something we could never duplicate. This act of creating an illusion, however, is an attempt to preserve nature's beauty, and thus it is an act of devotion. Artists' work also serves to increase other people's awareness of nature, and reminds everyone of our shared responsibility to preserve and defend it.

Artists are almost always intimate with nature because it is so often part of their subject matter. No matter how literal or abstract an artist's interpretation of nature may be, nature almost always molds an artist's conception of the universe in some way. And because nature is so varied, there are enough rhythms, forms, colors, and sizes to please the most diverse artistic tastes. Even the most easily bored of us need never find nature static, with its constantly changing cycles.

For the artist, who must by definition be creative, freedom in thought and action is essential. But because artists are not only lovers of nature but also members of human society, they have been trained (like everyone else) to conform to the norms of that society from a very early age. The rigid rules of a civilized culture can affect an artist's search for beauty. We are often fed idealized versions of what is beautiful—the way a tree "should" be shaped, the "correct" proportions for various forms, and so on. The further a thing varies from this accepted version of beauty, the more likely it is to be regarded as ugly rather than unique or interesting.

And yet a small child who has not yet been conditioned to fear or reject what is unknown and different will regard it with curiosity and delight. Children love to learn and explore. Our basic instincts, unthwarted, are to be attracted to a new phenomenon, using as many of our five senses as possible to experience it. More than most adults, artists must keep alive this childlike sense of wonder and fascination with discovery. It goes hand in hand with an increased sense of awareness: Artists tend to notice details that others miss. We see textures not as good or bad, nor even as usable or not, but as somehow amazing just because they *are*. If we are intrigued by certain terrain changes, silenced by a strange bird call, or compelled to seek out some eye-catching mountain range or sunset, then we are realizing our instinctive ties with nature. The more any of us listen to our instincts, the sharper those instincts become.

Painting in harmony with nature means painting with a mental attitude that encompasses an awareness of nature, and at the same time allows us to be individuals who approach art in our own unique way. This book is meant to help artists accomplish that.

In my first book, *Painting the Spirit of Nature*, I stressed the need for artists to open their minds to experimental painting. As a declared abstract naturalist painter, I hoped to encourage watercolorists to stretch their imaginations and techniques into more exciting and individual expression. Sharing the methods I used and taught met with rewarding feedback from many readers and students. For all those who asked when I was going to write another book, I take this opportunity to demonstrate the new techniques I've added to my paintings and workshops.

This book includes a number of ways to create natural textures by emulating nature's techniques. The sand paintings harness the natural forces for waves and wind to create rippled patterns. Paintings using natural and manmade fibers mimic some of nature's most delicate textures. Concentric rings and ridged effects are painted in the same way they are on rocks and sidewalks: by letting the sun evaporate water. You will also find techniques for portraying the multifaceted shapes of crystals, the earth's geological layers, the symmetry of reflections, and images from outer space and your own imagination.

STONE AND FOAM. Photograph by Maxine Masterfield. *Close-up of sliced sandstone aggregate.*

I have again included photographs by myself and others that help to illustrate the unending visual romance between nature and the artist. I believe this courtship is so successful because we are more often dealing with the essence of an effect rather than literal translation. For example, if I am taken with the movement and mood of fine grass undulating in the wind, I am free to translate that effect into the wispy texture of clouds. Here I am taking a quality of the wind and transferring it wherever it carries the impression I feel. By instinct I know that nature will always furnish what every romance needs: constant discovery. For romance is made of promise and mystery.

It is my wish to help artists listen more closely to the rhythms of nature that are expressed in the textures and structures we see. By considering and understanding the forces that produce the forms and systems we find on our planet, it becomes possible to emulate those effects and surfaces in our art.

The techniques presented in this book are those I have been teaching the last few years. My experimenting with each method in the beginning usually included trying hard to duplicate not only the effects in nature, but use of the same forces in the same way. Each time as I more clearly understood the relationship between the outcome and the process that achieved it, I was able to cut corners, saving time, effort, and disappointments. Above all I learned that an alliance with nature is the secret of painting in harmony with nature.

When I lived in Ohio, I had a favorite spot where a stream trickled over large boulders and smaller stones. After rains, the water foamed and surrounded the rocks at the stream's edges. In an overflow pond nearby, fairy shrimp appeared every spring. As Day Begins *reminds me of this magical place.*

I began this painting by pouring color mixed with water. As the color flowed, I dropped sliced, polished agates onto the paper. Then I placed a heavy plastic over the mixture until it was dry. When I removed the plastic, I chose the white that looked like foam or snow to be the bottom, and added treelike shapes to the top. I then collaged bright textured shapes from other paintings and connected the middle ground and foreground with white lines.

As Day Begins, Maxine Masterfield. *38″ x 60″ (97 cm x 152 cm), watercolors and collage on Arches paper. Collection of Mr. and Mrs. Howard F. Stirn.*

Interpreting Nature's Textures

ANCIENT RUMORS #5, Katherine Chang Liu. *30" x 40" (76 cm x 102 cm), mixed media on Crescent watercolor board. Collection of Dr. and Mrs. Peter Hirsch.*

"I spend a lot of time traveling to sketch ruins and crumbled walls, which give me wonderful compositional material for this series of paintings. For Ancient Rumors #5, I used layers of paint to build up the textures of various areas. Some pieces of watercolored paper are collaged on but blended in. In other places I created the illusion of collage with layers of paint."

Nature is full of fascinating textures, an assortment so diverse that our imaginations can scarcely encompass them all. From rocky cliffs sprayed with foam to downy milkweed pods drying in the sun, from pine needles dusted with snow to pebbles worn smooth in the bottom of a brook—nature provides us with enough textures to satisfy any artist's visual and tactile appetite.

The first and most important tool of the artist is the mind's eye. It not only sees nature, but searches out the details that make the difference—and remembers them. Part of our mind wants to pin a word, a title to the things we see. But a mere label of tree, flower, or sunset is not enough information for the artist to bring the illusion forth when it is needed. The details of form, proportion, color, and texture must be bound together with an overall impression of the subject matter that allows it to be remembered as a unique experience. Then the artist can work on a method to re-create it.

Those artists who love nature and continually strive for harmony with their surroundings yearn to capture not just the look, but the essence of nature's myriad textures. And there are many ways artists can achieve this—especially when the painting techniques mirror the methods used by nature itself. For example, we can allow paints to soak into or be resisted by prepared surfaces the way that nature allows rain to seep into the earth or drip off of nonporous surfaces.

In my first book I demonstrated experimental techniques that used plastics, cellophane, waxed paper, and other materials that were stretched, twisted, and weighted down over poured paints and inks to capture various natural forms. The techniques presented in this book are based on many of the same concepts, but developed further. Each method I have worked with had to pass through several phases of trial and error before I discovered the best ways to achieve the optimal effects. Even now, I keep finding new ways to use old methods. Creative techniques are never through being developed, any more than nature is ever through evolving.

Basic Techniques

Materials

Heavy watercolor paper such as Morilla 140 lb., which comes in sheets or rolls 48 inches (122 cm) by 10 yards (9.1 m)

FW colored inks, Steig Luma watercolors (both of which are lightfast and nontoxic), and thinned tube watercolors or acrylics

Plywood boards at least 1/8 inch (3 mm) thick, and staples or gum tape for fastening paper onto boards

Spray bottle with fine mist application for adding water

Air mist bottle, available from beauty supply houses, for fine mists of color

Plastic bottles with applicator tips, also found in beauty supply houses, for holding and applying colors

Soft rubber rollers for spreading and guiding colors

An assortment of brushes, including Japanese hake brushes for broad washes and fine liner brushes for opaque ink

Plastic drop cloths for covering works while drying

A movable easel (such as MobilEasel) that allows a plywood board to be tilted

Pouring the Colors

Prepare the heavy watercolor paper by wetting it, stretching it, stapling or taping it down to a sheet of plywood, and leaving it to dry. When you are about to start pouring colors, attach the board to a mobile easel so that you can tilt it to any angle. Then lightly mist the paper with water to help the colors flow freely and give the colored areas feathered edges.

Now you are ready to pour or squirt colors onto the paper. By tilting and straightening the board, you can influence where the colors flow. Keep your spray bottle of water handy so that you can thin out colors and add washes if necessary. Color or water can be added anytime to areas that seem either washed out or too concentrated. Remember to level the board when the colors are where you want them, before you start placing your texturing materials into the wet color.

Adding the Texture

At this stage you can place many kinds of objects on top of your wet painting. Natural objects such as shells, stones, leaves, grasses, and feathers work well. Woven fabrics, waxed paper, fine plastic wraps, medium and heavy plastics, foil, and even bubble wrap all create interesting textures, many of which echo effects found in nature. Just be sure none of your texturing objects will dissolve in water.

Wherever your texturing objects touch the paper, the wet color will be attracted and form puddles. As the painting dries, the pigment will be concentrated along the edges of those puddles. This means that the texture varies according to the contact material and how it is prepared. (For example, waxed paper can be crinkled, twisted, or folded before placing it into the wet colors.) Where nothing was touching the paper, the colors are free to mix while they dry, leaving no patterning or texture.

A large sheet of plastic can be used to cover the entire painting while it is drying. This will not only give a unifying texture to exposed areas as they make contact with the plastic, but will slow the drying process so that you can add more colors and water right under the plastic.

Defining the Results

Once the painting is dry, remove the texturizing materials. (Plastics and natural materials such as leaves and shells can be taken off when the

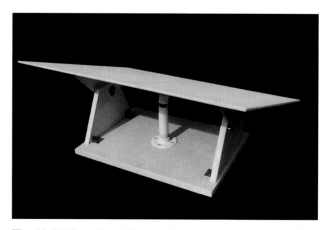

The MobilEasel's ability to tilt and rotate is very useful for controlling the flow of poured colors.

painting is still slightly damp, but waxed paper will fall apart if you try to remove it before the painting is completely dry.)

Rarely is a painting complete when you remove the materials, but you will usually have an immediate impression of what the painting is striving to be: The pattern usually suggests a particular element in nature by its inherent line and rhythm. At this stage you can help the image along by adding lines and washes, and sometimes by eliminating elements that intrude.

To many paintings I add opaque white lines with a liner brush. The addition of line and detail to focus on an area or set a strong directional pattern is often important to a work.

With many other works, I have added colors by repeating the process with additions of colors and textures in selected areas. Still other times I have painted over large areas with an opaque wash, to remove what I did not want. Other methods of using only some areas include masking and spraying over with an air mist bottle, and of course cutting areas of several works and collaging them together. Combining these methods until I am satisfied is a regular practice.

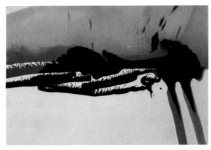 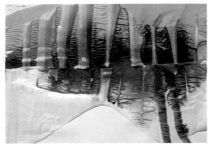 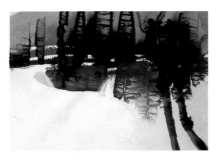

Here I poured yellow (almost squirted it from the plastic applicator bottle) first horizontally, about a third of the way down the paper. I then tipped the board slightly, so that the yellow flowed smoothly to the edges. After leveling the board, I added red below the yellow in two horizontal lines, so that some of it blended with the yellow. The blue was added last, in several shorter lines.

Using a soft, wide brush, I opened two paths for the red and blue puddle to flow down. With the board level, I also misted water over the colors to keep them loose and liquid until I was ready to place texturing objects into them.

I carefully placed several lengths of accordion-pleated waxed paper on top of the wet colors. The colors spread and crept under the contact areas, forming veins of feathered lines. I did not cover the painting with a plastic while it was drying, because I wanted open spaces free of color and texture.

I further defined some areas with white line, and cleaned up others with white ink. I then cropped the painting for a closer focus and titled it Waterfall.

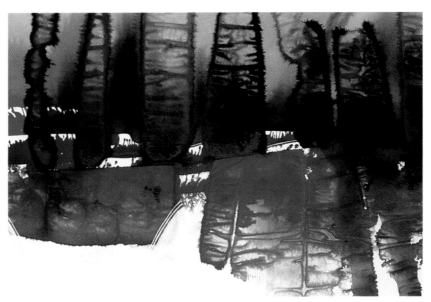

WATERFALL, Maxine Masterfield. *22" x 30" (56 cm x 76 cm), inks on Morilla paper. Collection of the artist.*

Stones and Shells

To create a texture that resembles a cowrie shell, pour a flat layer of white ink over brown-toned paper and sprinkle canning salt evenly onto the wet surface. Then put plastic bubble wrap over the wet paint and weigh it down to keep contact until the paint dries.

To achieve a pattern similar to sliced sandstone, brush a light coat of FW white ink over brown-toned watercolor paper. Place a heavy plastic over the wet ink until it is thoroughly dry.

For this look reminiscent of sliced, polished Brazilian agate, stretch thin plastic wrap over a watercolor wash while it is still wet. Pull the plastic into creases, allowing the color to be trapped in the folds. Let the color dry completely before removing the plastic film.

This texture looks much like sliced mottled stone. For this effect, brush an even, medium coat of FW white ink over a gray surface (either dry painted paper or gray-toned watercolor paper), and cover it with a heavy plastic until the ink is completely dry.

Leaves

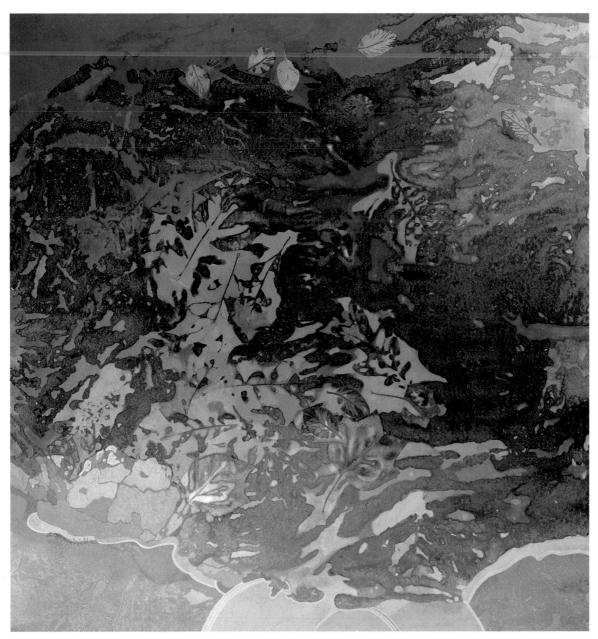

Andromeda Shadows, Maxine Masterfield. *44" x 42" (112 cm x 107 cm), watercolors and inks on Morilla paper. Courtesy of The Alan Gallery, Berea, Ohio.*

A stroll through the northern woods during autumn is a good place to find leaves for patterns. Leaves last for many years and can be used over and over.

For this painting I lightly poured a mixture of watercolor and ink over the paper, and then placed down leaves and a sheet of waxed paper. The crinkling and warping of the paper not only added texture around the leaves, but transferred some of its wax to the surface of the painting, leaving a sheen.

When using this method, be sure not to pour too much color, but use a lot of water around the edges of the pour. This allows the color to travel under the waxed paper. When the entire surface is dry, lift the leaves gently so that they can be used again.

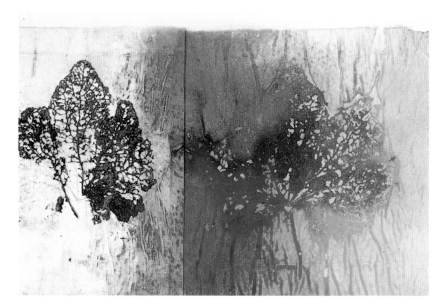

This weathered leaf, reduced to a skeleton of intricate veins, clung to the waxed paper as I lifted it off the watercolor image. To the tracery form of the leaf was added the texture of the waxed paper as the moisture warped and rippled it.

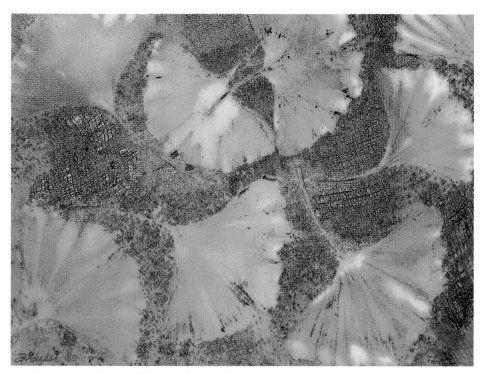

IN RESPONSE, Susan Abercrombie Ardussi. *8″ x 11″ (20 cm x 28 cm), inks and gold powder on Archette paper. Collection of the artist.*

"I chose leaves from the ginkgo tree because their half-circle shapes and curving stems gave the swirling, falling leaf movement that I wanted to convey. After dampening the paper with water, I laid open-weave cheesecloth down in an open pattern. I then poured yellow ink over most of the surface and added drops of burnt sienna and turquoise. I then put drops of different colors on each leaf (burnt sienna, red sepia, and black) and placed the leaves, inked side down, into the wet ink on the paper. To emphasize the glowing golden-light quality of the painting, I sprinkled on some Maimeri gold powder. I covered the painting with plastic wrap, weighted it, and let it dry for four days. After removing the plastic, but while the leaves were still in place, I sprayed a super-fine mist of red, then turquoise, and allowed it to dry."

Bark and Dense Foliage

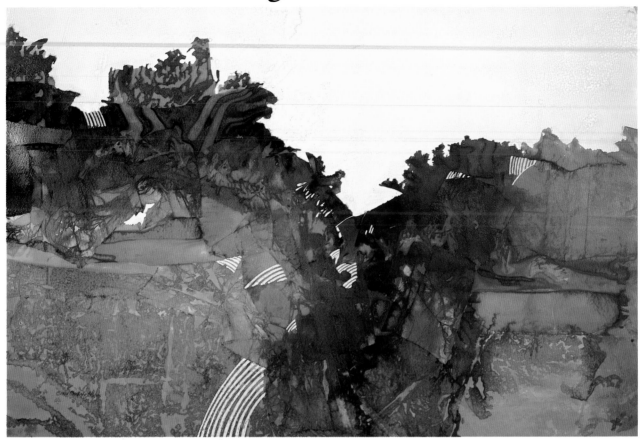

MORNING HOURS, Maxine Masterfield. *35" x 50" (89 cm x 127 cm), watercolors and inks on Morilla paper. Courtesy of Kanes Furniture, Sarasota, Florida.*

In Howard Stirn's photograph, the deep shadows within the crater where a branch was broken off heighten the drama of the rich texture. When I was working on Morning Hours, *I started to get the feeling of similar craggy, weathered bark in the shaggy profile of my dawn scene. I used plastic and light film over a pour of watercolors and inks, and added opaque lines with white ink after the colors had dried.*

WOOD SHADOWS. Photograph by Howard F. Stirn.

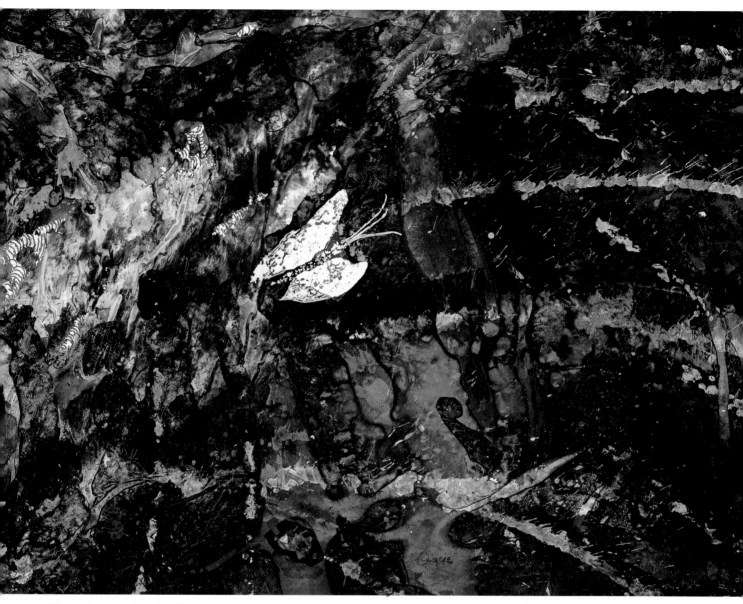

MOTH IMAGE, Gracie Hegeman. *17" x 23" (43 cm x 58 cm), water media on Morilla paper. Collection of Mr. and Mrs. Mel Griffin.*

"I had foliage in mind when I began this painting and was surprised when the moth appeared. I poured gold ochre and indigo inks to make green, red to complement it, and white to get contrast. Then I covered it with plastic sheeting and let it dry.

"To bring forth the moth that had emerged, I defined its wings and antennae with white ink."

Sedimentary Rock

This was a painting from my bright-colors series using rainbow pours of red, lavender, blue, and yellow inks. I placed a large, heavy plastic over the pour and weighted it down, being careful to trap air bubbles under the plastic. (It is the trapping of air that caused the rocklike shapes.) After the covered painting dried, I removed the plastic and decided the painting looked like layers of earth.

At this point, the central colors looked good, but the foreground and background needed to be established. I washed in a layer of tinted white for the sky and added some salt for a slightly mottled texture similar to that of large, worn boulders. In the foreground I had left a large area of white, and I decided it looked like a fence. For a final touch I added the white line drawing: a fence I felt I could stand behind and look out to the edge of the earth.

BEYOND THE EDGE, Maxine Masterfield.
38" x 44" (97 cm x 112 cm), inks on Morilla paper. Private collection.

Geological Textures

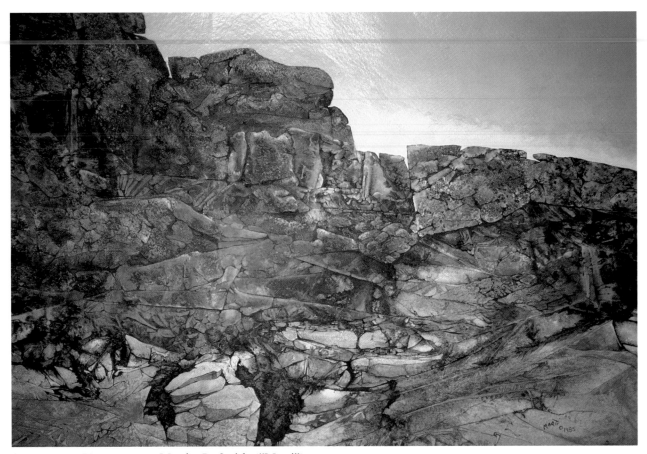

Southwest Vibrations, Martha L. Smith ("Marti"). *23″ x 34″ (58 cm x 86 cm), mixed media on Morilla 140 lb. paper. Private collection.*

"I began Southwest Vibrations *by pouring a mixture of ink and white acrylic over the paper in a random pattern and texturing it with crumpled waxed paper, acetate sprayed with Pam, and thin plastic.*

"After removing the plastic, I used watercolor and brush to develop the different textured areas into rocklike shapes. Much of the lower portion of the painting was refined with collage: I moved some rock shapes by cutting them out with an X-Acto knife, and I also collaged on discarded fragments from another painting. I sanded and repainted the sky several times to make it smoother. The lower rocky section was also repainted with a blue-gray acrylic and ink mixture, and covered with crumpled waxed paper and weights until it dried.

"In all my paintings I try to create a sensation of movement, even though the nature of the forms is sedentary. The swirling patterning of the rocks was planned to accomplish the effect of lines that lead to the top, after gaining momentum."

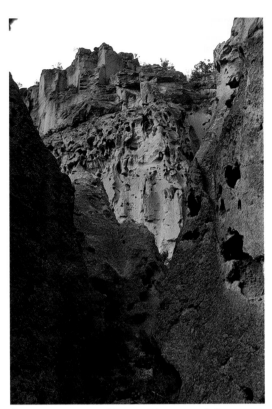

CANYONS IN THE WEST. Photograph by Elden Rowland.

CASTLE IN THE SKY, Martha L. Smith ("Marti"). *62" x 25" (157 cm x 63 cm), mixed media and collage on Morilla 140 lb. paper. Private collection.*

"When I explore abstract shapes, I find the concept of rocklike forms constantly resurfacing. Most of my paintings depict this subject in a realistic style with abstract reflections. I have always had a fascination for geologic forms."

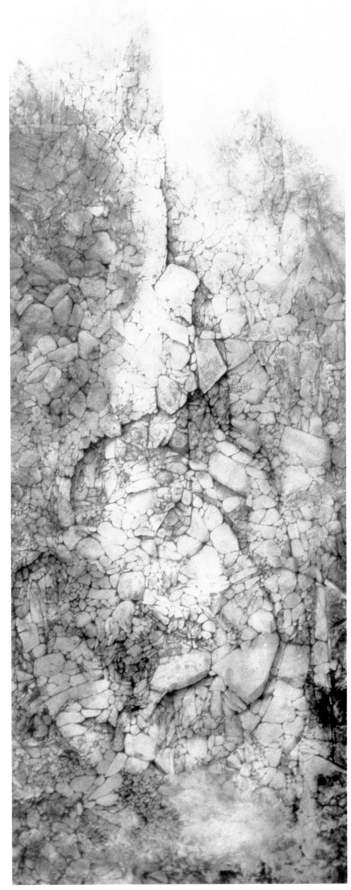

Sea Foam Against Rocks

RELENTLESS TIDES, Maxine Masterfield. *38" x 44" (97 cm x 112 cm), inks and watercolors on Morilla paper. Private collection.*

Sometimes during hurricane season the roar of the waves crashing against rocks can be deafening. The white spray no sooner falls away from the rocks than the next wave hits.

In this piece, I used waxed paper and film with some salt crystals. Later I not only added a white pour, but drew in white lines to give clearer direction to the rising and falling foam, and to outline the lava-like edges of the silhouetted rocks. The textures of the flowing, frothing water and the jagged rocks form a vivid contrast.

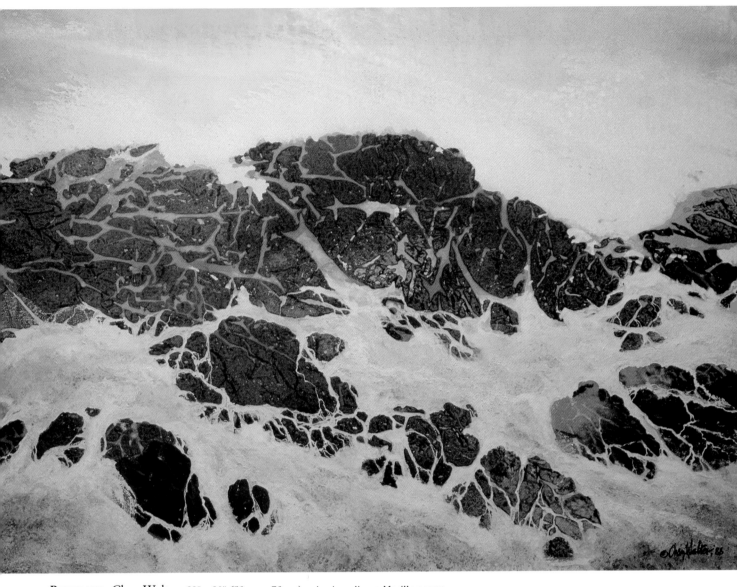

RIVULETS, Chaz Walter. *22" x 30" (56 cm x 76 cm), mixed media on Morilla paper. Collection of Alan R. Anaral.*

"In Rivulets, *the preliminary image created by pouring inks suggested massive, rugged rock forms with a sea breaking over them in a wild and boisterous manner. I wet the sky area well and poured orange and yellow inks into it. While this was still wet, I poured white liberally along the upper edge of the rock mass to define its shape. I then tilted the board in several directions to make the white flow into the orange sky, creating a moving cloud formation that would intensify the turbulent feeling.*

"When this area was dry, I used modeling paste in the foreground, applied with a rough brush, to create a textured surface of sea crashing on the rocks. I did not allow the paste to set, but rewet the whole and poured sea tones, tilted the board, and added salt for more texture. When satisfied with the general mood, I pulled the foreground together with a fine sable brush, using white ink to shape and define the rocks and waves."

Water

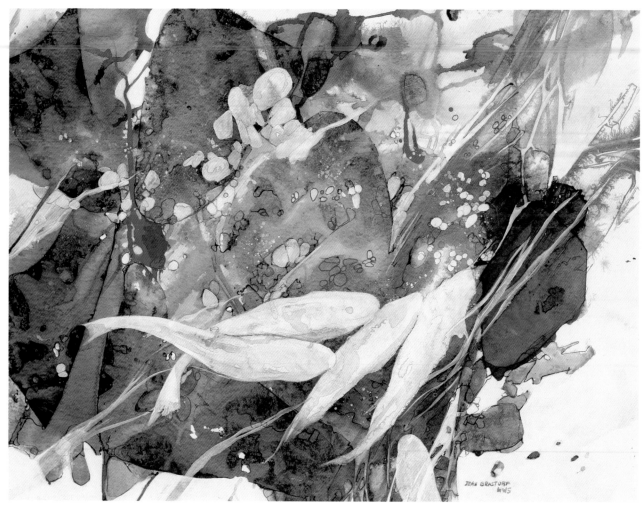

STREAM, Jean Grastorf. *31" x 40" (79 cm x 102 cm), inks and acrylic on Morilla paper.*
Collection of the artist.

"As a child in rural New York state, I spent much time visiting the creek
and river near my home. A special delight was discovering new pools of
deeper water left after a spring rain. These often contained large fish
where normally only small crabs and minnows were found. To paint
Stream I had only to imagine myself back in the cool rush of my creek,
discovering the treasures lying just below the transparent surface.

"I began this painting by taking my paper, ink bottles, hake brushes,
plastic sheets, and plastic wrap outdoors. I flowed a diluted mixture of
raw sienna, burnt sienna, and ochre inks over the wet paper. Then I
covered this very light underpainting with the plastic wrap, pulled tightly
to suggest a diagonal flow of water.

"Once this had dried in the Florida sun, I cut rock shapes from heavy
plastic, laid them down on the work in a planned pattern, and squirted
stronger inks under them. Again the sun hurried the drying process. I
added the fish, more rocks, and bubbles with white acrylic and gold ink."

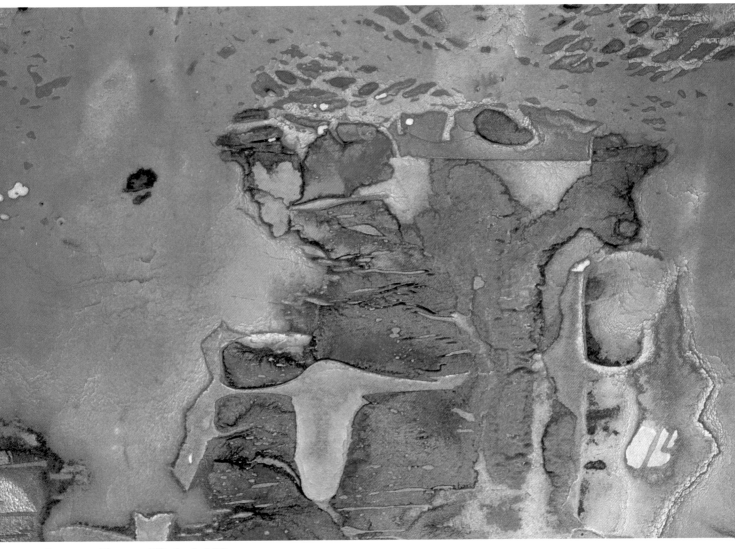

ATLANTIS FOUND, Elizabeth Miller. *22" x 30" (56 cm x 76 cm), inks on Fabriano
Artistico paper. Collection of Charles Anderson.*

*"It seems that every painting I undertake has a dominant theme of one of
nature's wonders. I suppose that water and its reflections intrigue me
most, but seeing an aerial view of the countryside absolutely fascinates
me, and seems to appear again and again.*

*"This painting was begun by pouring various hues of blue, red, and
violet inks and allowing them to mix spontaneously. Where one color
flowed to join another, small islands of color remained undiluted and free
of surrounding hues. To preserve the brilliant colors, I didn't tilt the board,
but began laying small irregularly torn pieces of waxed paper over the
areas I wished to preserve. The blue inks merged over the lower portion
of the paper, forming an image that strongly suggested to me an aerial
view of land and water. At this point, I laid a piece of netting into the blue
portion to heighten the rippled watery look. I then covered the whole
painting in heavy plastic and allowed it to dry overnight. When I removed
the plastic, the overall look of the paper was like soft suede."*

Painting with Sand

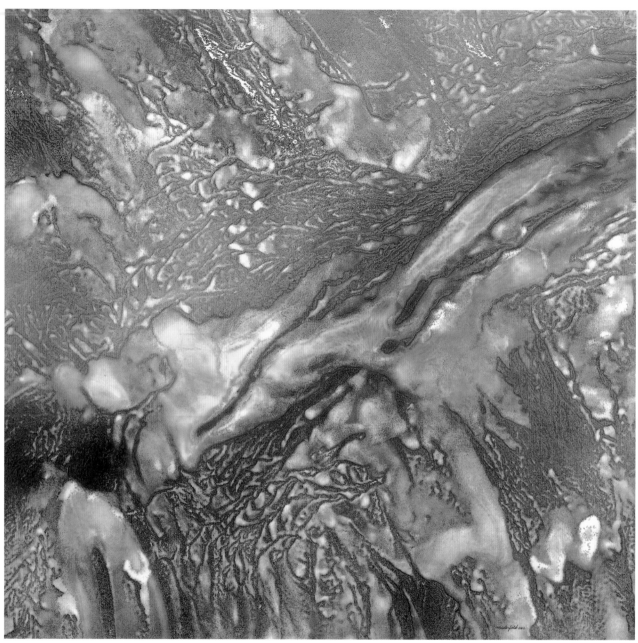

THE NATURAL WORLD, Maxine Masterfield. *44" x 46" (112 cm x 117 cm), inks on Morilla 140 lb. paper. Collection of the artist.*

For this painting, I sprinkled a heavy layer of sand over watercolor paper and lightly misted it with water. While the sand was still wet and the patterns distinct, I sprayed rhodamine and indigo inks over the entire surface.

Once the painting was completely dry, I brushed off all the sand. The areas where the sand was dense are still nearly white, but the paths worn through by the water are richly stained by the inks and preserve the rivulet designs.

I'm especially drawn to the shore in the early mornings. It's not the horizon that interests me, but the harvest of sand.

I search through what the morning tide has washed in. I marvel at the rippled patterns left at different levels of the beach. When there are only bird and crab tracks over the intricate designs, before other early risers come out and comb "my" beach, I can feel that this is the meeting place of earth and water, a place of eternal change. No two mornings are exactly the same. Each area is like a signature, a fingerprint of nature.

On one of my morning walks I became particularly fascinated by the rhythmic patterns formed in the sand by the action of the waves. I began to imagine a sheet of watercolor paper at the edge of the beach, covered with sand and washed over by waves, so that rivulet patterns would be left on it. Would it be possible to capture the patterns of the beach that way? My excitement grew as I determined to try it.

I hurried back to my studio and returned with watercolor paper attached to a large plywood board. It was near hurricane season and the wind blew dry sand off the board. Wet sand wouldn't stay evenly on the surface, and when I took the board to the water, the first waves washed all the sand off. Luckily a woman on the beach suggested that I stop fighting the waves and use the tide pools. That did it.

At a tide pool I tilted the board and slowly added sand and water. Patterns began to appear. I carefully carried the board to my station wagon. After a cautious ride to my studio, I began spraying colored inks onto the sand to capture the patterns. For the next few months I experimented with various techniques.

I discovered that the tide patterns I was trying to duplicate had to be *miniature* versions of those on the beach. (Even a large sheet of paper could contain only a tiny corner of the ripple patterns created by ocean waves!) I also found that very little sand was actually needed on each stretched paper to capture the rippled designs.

Now I have refined my technique. First I sprinkle a thin layer of very fine sand on smooth paper. (Rough paper doesn't work.) To simulate the wind, waves, erosion, and retreating tides, I spray a light mist of water over the sand until a shallow layer of water floats over it. If the board is tipped, the water will rush through the sand, leaving a rippled design similar to that left on a beach by the water receding at low tide.

To preserve the sand design in a more permanent form, I then apply inks and paints in a fine spray. The sand acts as a resist to absorb the color and produce lighter sections of the finished painting. Different effects can be achieved by first "drawing" into the sand, pressing in various objects, or varying the drying time between spraying on the mists of water and of color.

Sand painting captures the graceful patterns of flowing water. Any artist who has happily wandered barefoot over rippled sand on a beach will enjoy this technique.

Basic Techniques

Materials
Papers: Morilla 140 lb. watercolor paper, smooth side of cold-pressed paper, illustration board

Artcor (a sturdy, water-resistant foam-filled board ¼ inch thick)

Air mist bottles (one for each color and one for water)

FW colored and Rotring inks

Watercolor inks

Whisk broom (to remove dry sand from finished painting)

Large pump sprayer (as used in garden) for water

Fine sand (be sure it's ground quartz, not glass)

Mesh sifter for sand (the colored sand that is removed from the finished painting can be reused if sifted first)

Small plastic pails for pouring water

Paraffin or wax crayons for line and spot resist

Sliced shells, sea fans, coral, and so on for pressed designs

Mobile easel (see page 12)

Setting Up Your Materials
For best results, sand paintings should be allowed to dry undisturbed. This means that you should do the painting in whatever place you intend to let it dry.

Staple a piece of cold-pressed paper, smooth side up, flat to a board; tape doesn't work as well. I prefer to start with white paper, but paper on which a color wash has dried can also be used. It's important to let the wash dry first if you don't want the new colors to mix and muddy. Ink, acrylic paint, and various other permanent-once-dried colors can be used for washes.

If you want your painting to include the shapes of light, fine-lined objects such as net or sea grasses, lay them onto the paper before adding sand. If you want the shapes to show as colored lines, lift the objects before spraying on the color—but after spraying on the water, so that the sand is damp enough not to fall back into the design crevices. If you prefer the objects to leave white lines with colored edges, keep them on the painting until after the color is dry.

Adding the Sand
Either use a sifter to sprinkle sand onto the paper, or presift the sand to remove any debris and then throw it across the paper. It is best to start with an even, light layer of sand—⅛ inch (3 mm) is plenty.

At this stage you can make sweeping windlike designs in the dry sand with a fan, hair dryer, or straw. You can also scrape across the surface or press objects (such as sliced shells or coral) down through the sand. Be sure to press down all the way to the proper surface if you want clear color lines or areas of color with no sand texture. To keep the edges of the object's shape clear, leave it in contact with the paper while you spray on the water.

Spraying on Water and Color
Slowly apply a light spray of water over the sand areas while tilting the board in the directions where you want the ripples to go. It is best to spray from the middle and tilt to let the water wash through the sand and off the board, carrying the excess sand from the depressions of the design with it. The thicker the sand, the less color will penetrate to the paper underneath.

The drying time after you spray on the water is very important. If color is applied immediately after the water, the painting will be soft, with diluted color penetrating through the wet sand to reach the paper. Some color may also flow off the paper with the still running water, causing a leopard-skin effect. If the sand is left to dry completely before the color is sprayed on (which takes about a day in the sun or up to a week indoors), the result is white paper wherever there was sand, and strong color with hard edges wherever there was no sand. Of course you can experiment with many intermediate states of dampness, or even apply some colors while the sand is wet and others after it is dry. The sand lightens as it dries. You can test it for dryness by sticking your finger into the deepest part of the sand.

When you are ready to add color, keep the

board flat. Using an air mist bottle, spray the lightest color over the sand, and gradually work up to the darker colors. Inks work best for this technique. Be sure to allow the painting to dry completely before brushing off the sand, or the colors may smudge. It's best to test the dryness as described above.

Simply tilting the board will cause the dry colored sand to slide off. If some sand sticks, remove it with a whisk broom.

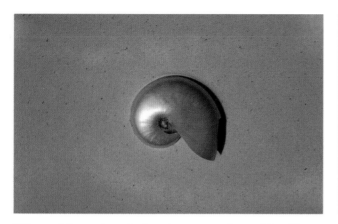

Sift sand through a strainer to remove impurities. If you like, push cut shells into the sand to open a shape.

Spray the sand lightly with water to set the shapes; the dampened sand becomes heavy enough not to move if the board is tipped. Spray on more water and tip the board in different directions to form rivulet patterns as the water runs off.

Now spray color over the sand and into the areas where the sand has been washed away. Notice how saturated the sand is with the color.

When the painting is completely dry, brush off the sand. You will see a pattern of lighter sections where the sand absorbed color, and stronger color where the water exposed the paper surface.

Controlling the Sand and Water to Create Natural Patterns

In a variation on the sand painting process, leave the sand dry once you have sifted it onto the stretched paper. Then pour on water from one end only, with the board tipped. The water will run through the dry sand, washing narrow paths away and leaving branchlike openings, as in the early stage of Chameleon *shown at right. You can then add more water—even from a different side. When the design is finished, spray on water to set it, and then add color.*

In this instance I saw the chameleon shape in the branches, and added the touches necessary without blowing his camouflage cover. The painting was also cropped a great deal to focus on him.

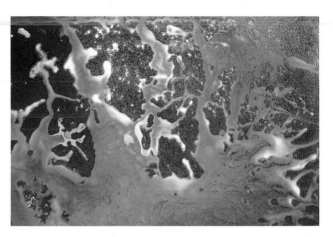

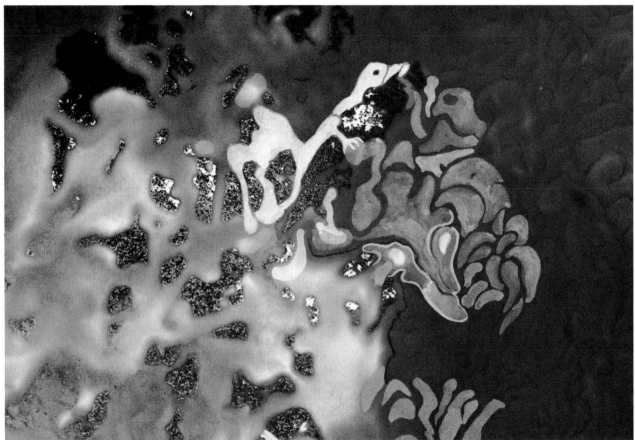

CHAMELEON, Maxine Masterfield. *21" x 30" (53 cm x 76 cm), inks on Arches cold-pressed paper. Private collection.*

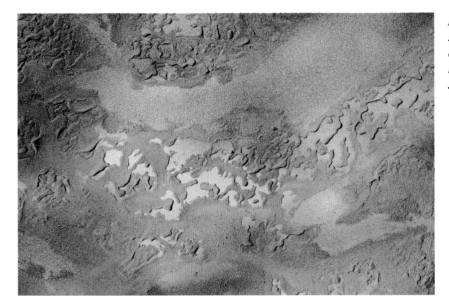

Here I added a second layer of sand to create a new pattern over a dried, pale sand painting. (See more about this technique on page 36.)

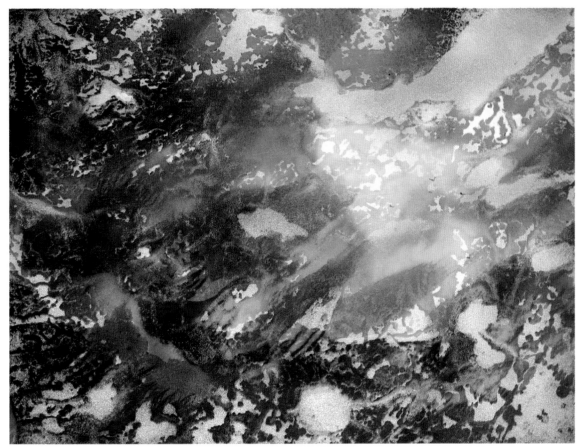

GULL COAST, Maxine Masterfield. *22" x 30" (56 cm x 76 cm), inks on Morilla paper. Collection of the artist.*

To form cloud patterns, throw water onto sifted dry sand. For Gull Coast, I worked outside and used a bucket to splash the water onto the stretched paper, which lay on the ground.

The splashes of water cleared out sandless patches that were uneven and amorphic—perfect for a sky texture. As a finishing touch I added flying seagulls in the misty water spray above the rocky, churning coastline scene.

Drawing in the Sand

You can create specific patterns by drawing directly into the sand. Tools or your own fingers are fine, and you can smooth out the sand and redraw until you are satisfied.

Drawing can be done in wet or dry sand. Each has its advantages. Dry sand (shown here) does not clump up in front of your tool, but it can fall back into narrow lines, leaving broken-lined images. Be sure to mist the sand to keep it in place, once you have the pattern you want. Then spray on color. A pattern will remain after the dried sand is removed.

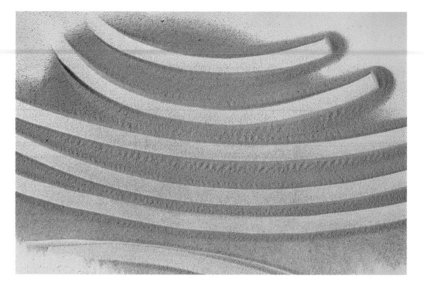

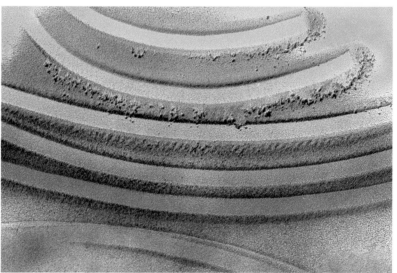

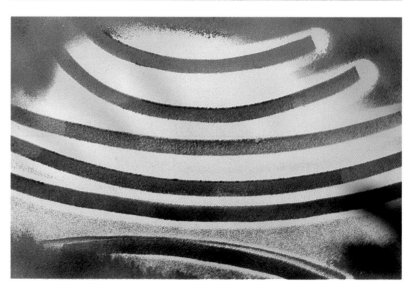

Using Resists

Wax allows you to draw more intricate designs. (Here it has resisted color in lines and small circles.) Draw any design on dry paper with a wax batik tool or a paraffin stick. The design will remain white (or preserve whatever underpainting is already on the paper). Then add sand, water, and color as usual. After the painting is dry, scrape off the wax with a flat-edged tool that is not razor sharp. A credit card works just fine for this.

You can also use objects as resists. Try pressing coral or any other open-patterned object into a thin layer of wet sand, being sure that the object firmly touches the paper. When you lift your object, its pattern should remain, ready to absorb sprayed inks.

To create patterns with larger shapes, place flat objects on the paper before sifting on sand around them. Lift them off carefully and use a delicate spray of water to set the sand in the pattern—or, if you want white shapes with colored edges, leave the flat objects on until the sand is dry.

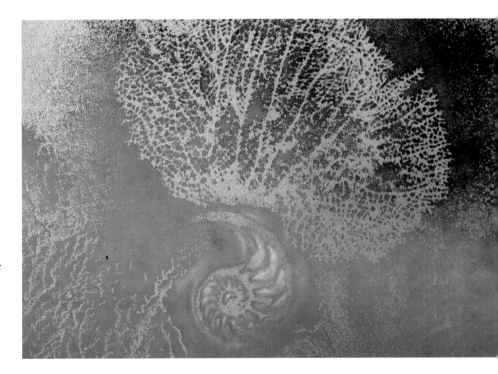

Further Advice on Working with Sand

Using the sand method on Artcor creates a very different effect than on absorbent, textured papers. Instead of permeating the surface, the color beads up and gives an appearance similar to coral.

Using various sizes of grains of sand in different areas of the same painting leaves interesting textural changes. You might even want to experiment with other types of granular materials to see what happens. Always test first on small pieces. Beware of any sand or dirt that contains plaster or concrete powder in it, because such sand will harden and strip your paper when you try to remove it. Also, some materials may have impurities that will affect your colors by bleaching them, changing their hue, dirtying them, or making them settle unevenly, creating blotches instead of the texture you want.

Sometimes after all the sand is removed from a sand painting, the results are too pale and uninteresting—all over or in isolated sections. The painting can then be developed further. If you have freed it from its board, restretch and fasten it down tightly once more. Then follow all your original steps, being careful this time to leave enough open patterns to register the inks, and to use deeper colors than the first time. Sometimes the problem is that all the colors were allowed to merge into a muddy gray. If you isolate the hues by using rippled sand "trenches" to contain them, they will keep their purity. Be sure the painting dries undisturbed, level and completely, before you brush the sand off the surface.

If only certain portions of a sand painting need to be redone, sift sand only onto those areas. (Don't try to use sand to mask the parts that are all right. Because you cannot see them, you may inadvertantly invade them when you tilt the board to form patterns.) If the sand does not form an unbroken boundary to keep the new colors away from the saved areas, tilt the board slightly to keep the water and colors away. If the area you wish to save is in the middle of the painting, redo one edge at a time, always tilting the flow away from the finished areas that you want to preserve.

Blowing the sand away is another method of redoing a sand painting when there are various areas that need a splattering of texture here and there, with an unconnected feel to the design. Sift the sand lightly in the needed areas. Then instead of spraying all the sand with water to hold it or create a pattern, drip or trickle water onto the sand exactly where you want the light areas of the design to be. You then can either tilt the board and let the remaining sand fall away, or use a hair dryer or fan on low to blow the dry, light sand off the painting. Spray your colors carefully, and allow the painting to dry completely before brushing the sand away.

This painting contains not only the water flow, but the shells and other debris that mingle on shore beneath reflecting waters. The setting sun casts its colors onto the water. There even seems to be a last veil of shadows, as if clouds were passing overhead.

Shells and fossils were pressed into the sand before the pattern was established, and the bottom areas were exposed surfaces where the deep colors formed the shadows.

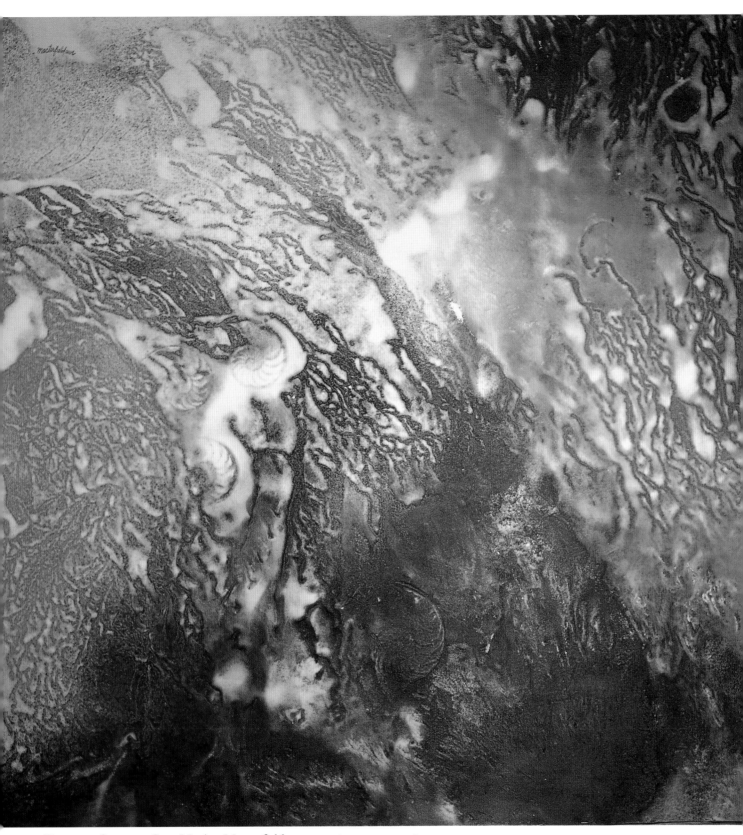

DUET OF SEA AND SKY, Maxine Masterfield. *46" x 46" (117 cm x 117 cm), inks on Morilla paper. Private collection.*

Letting the Sand Determine the Subject

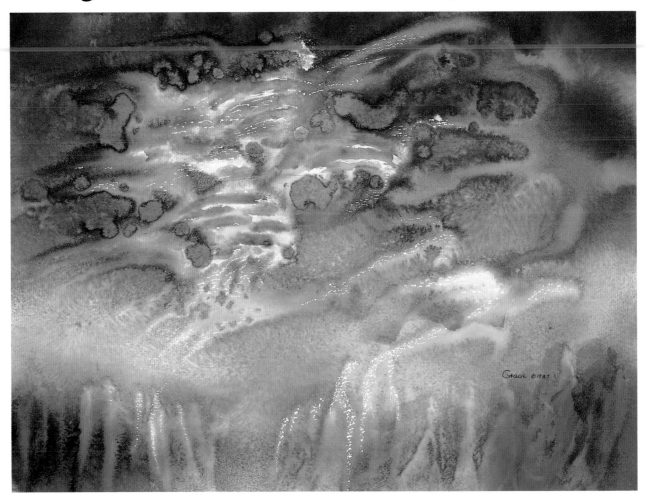

SEEKING ITS LEVEL, Gracie Hegeman, *22" x 30" (56 cm x 76 cm), inks on Arches 140 lb. cold-pressed paper. Collection of the artist.*

"Seeking Its Level *began without an idea in mind. I simply flung sand in two opposing directions, one vertical in a narrow band along the width of the paper, and the other horizontal over the rest of the surface. I added water to the horizontal band as I tilted the board back and forth. I also flicked some water from my fingertips for a different texture. I sprayed the inks in my usual light-to-dark manner and left the painting to dry.*

"When I scraped off the sand I was delighted to find the forms of rock ledges. I began to make sparkles in the water with white ink, but became unsure of myself and stopped. I propped the painting where I could see it several times a day, confident that I would get an idea of how to proceed. One day I turned it upside down and found a better painting that needed only a few more sparkles on the water."

WET ROCK LEDGE. Photograph by Howard F. Stirn.

Evoking the Memory of a Specific Place

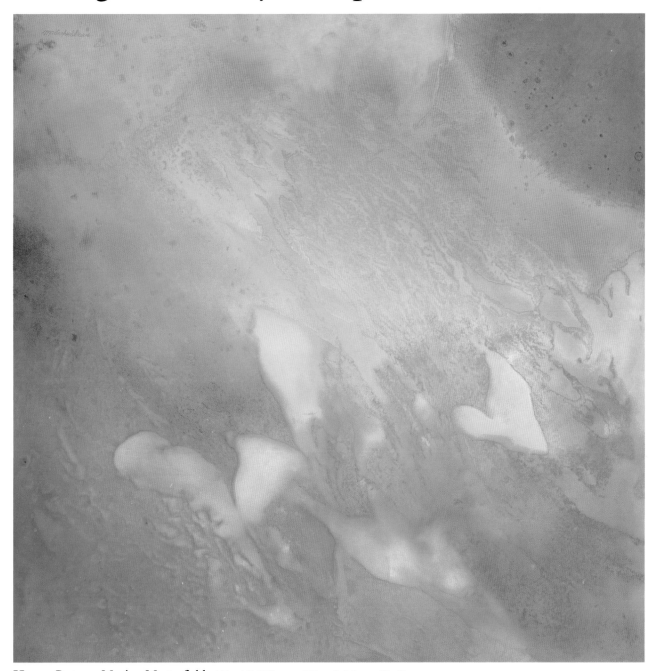

HEART BEACH, Maxine Masterfield. *44" x 44" (112 cm x 112 cm), inks on Morilla 140 lb. watercolor paper. Collection of the artist.*

I used to walk along a stretch of Myrtle Beach in South Carolina where I found heart-shaped shells. I completed this painting shortly after, and the shapes and colors reminded me of that stretch of beach. The heartlike shapes were built-up piles of sand, which absorbed most of the magenta ink.

Combining the Random with the Geometric

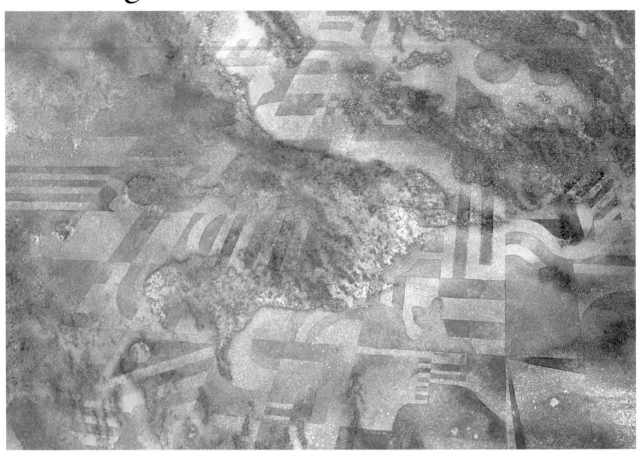

WINDOW SEAT 10C, Kathleen Conover Miller. *22" x 30" (56 cm x 76 cm),*
watercolors on Arches hot-pressed paper. Collection of Dr. and Mrs. Richard Tholen.

*"Paintings that include organic forms and movements along with
seemingly oppositional straight, mechanical edges are the most exciting
to me. Combining these forces produces a wonderful synergy!*

"The primary inspiration for the Window Seat *series is the Midwest
farmlands as seen from an airplane. Each* Window Seat *painting was
done separately, with the rhythm of the clouds and the color application
altered to show a change in viewpoint from one airplane seat to another.
The larger geometric shapes were cut from waxed paper and laid onto the
wet paper. I added sand next, then water, then inks. The sand created the
swirling cloud patterns, and the waxed paper sometimes acted as a resist
and other times trapped color below it. I finished the painting by brushing
in some of the fine details, such as the smallest shapes in the patchwork
of fields."*

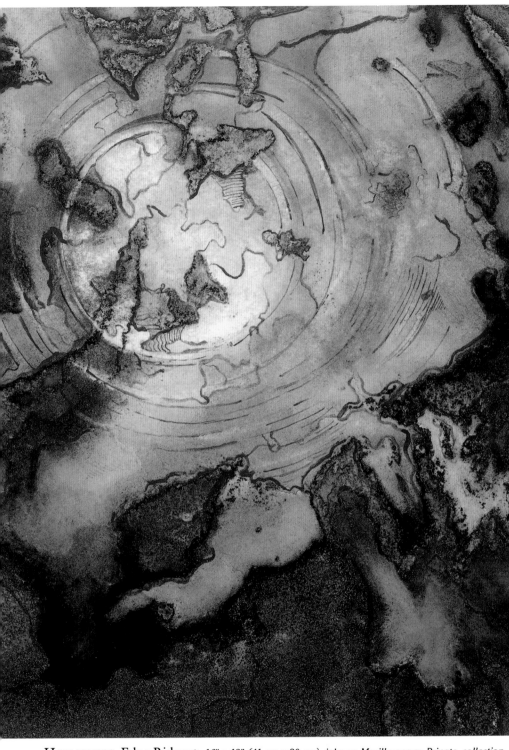

"This painting was made on a mobile easel. I drew hard, distinct lines into fine silica sand, the kind used for sandblasting, which contains mica.

"Originally this was part of a larger painting, but once I brushed the sand off, I was so intrigued by the unexpected appearance of a white dove shape that I cut it away from the rest of the design, toned parts with Winsor blue watercolor, and penned widening rings in gold ink to finish the painting. Some sand and mica adhered and were left to gleam. The finished work reminds me of looking up into the sky through dark stormy clouds. The wind is rushing and parting clouds in its path toward the viewer. The concentric lines give the feeling of the earth spinning."

HARMONICS, Edna Rideout. *16" x 12" (41 cm x 30 cm), inks on Morilla paper. Private collection.*

Suggesting Marine Life

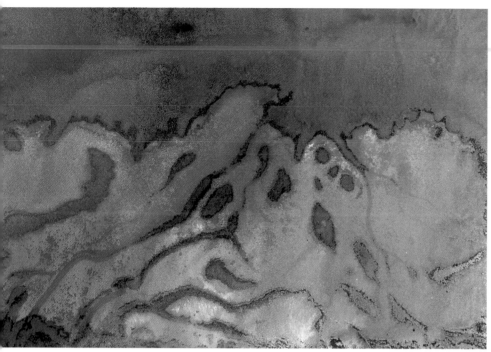

"After the sand painting was completed, I left it in the sun to dry. When I tried to remove the sand, some of the stained sand clung in areas and formed strong, dark edges to the amorphous shapes. I decided to leave it that way and sprayed clear varnish to fix it in place. Now the painting seems to me like sea fans forming, growing and reaching up toward the surface of the water to the source of light."

REACHING OUT, Mary Ann Beckwith. *26" x 40" (66 cm x 102 cm), inks on Arches paper. Collection of the artist.*

"When scuba diving, I've seen coral gardens similar to those in Sea Bottom. First the paper was heavily stained with yellow, and then I applied the sand method. I liked the sand on the painting because it looked like coral, so I just blew off the loose sand and sprayed the heavy portions with indigo, preserving the open spaces of yellow. I then added several coats of half semigloss polymer and half water, fixing the sand to the paper surface. The polymer dries pliable, ensuring that the sand will remain in place securely."

SEA BOTTOM, Dan Mihuta. *21" x 30" (53 cm x 76 cm), inks on Arches paper. Private collection.*

Superimposing an Image

BILL, Steven L. Rieman. *22" x 30" (56 cm x 76 cm), watercolors on D'Arches 140 lb. paper.*
Courtesy of Alpha Gallery, Denver, Colorado.

"When I stretched the watercolor paper for Bill, *I integrated the stapling process by developing a pattern of staples within the picture plane. This painting began as an exercise in using nature's own processes of depositing and eroding to create an interesting textural surface, while alluding to man's regularity and orderliness via the staple pattern.*

"I then broadcast silica sand (grit #60) over the entire surface. With an ear syringe filled with wet, white clay slip (runny mud), I drew a nonobjective design and then took the piece into my backyard to dry. As the clay dried, the breezes stirred and removed some clay flakes. I recorded this process by periodically applying atomized watercolor paint to the entire surface; the exposed areas received the paint.

"When I had achieved the patterns, textures, and colors I wanted for the background of my painting, I removed the remaining dried clay, sand, and staples within the picture plane. I then covered the entire painting with a sheet of clear acetate. After deciding to superimpose the image of my brother Bill over the background, I cut lines in the acetate where I wanted hard edges to appear, such as along the outer edges of the arms. Next I used a small sand blaster to create the lightest areas by removing some of the paint to reveal various layers below. The acetate served as a mask in this process; wherever I lifted a flap, the sand blaster etched away one hard edge where the acetate was cut, and a more gradual edge inward under the flap.

"I finished the image by painting some dark negative areas (such as those between the arms and head) with watercolor and a brush, to increase the value contrasts."

Working with Rich Color

MIDDAY LIGHT, Maxine Masterfield. *46" x 46" (117 cm x 117 cm), inks on Morilla paper.*
Courtesy of The Alan Gallery, Berea, Ohio.

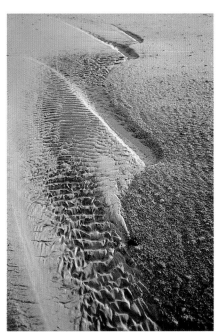

Water can take on any shape or mood, depending on its container and the elements that dictate its form. Moving water has the power to shape its own container, the way it sculpted the sand on the shore in this photograph.

BEACH SCULPTING. Photograph by Nadine Allen.

Quite often the colors reflected in water seem exaggerated when compared to their origins. Riding under the sky blue and bright white reflective surfaces of the water in Midday Light *are the deep colors and patterns of rich, dark sea sands and the tiny colorful inhabitants of coral and shell particles.*

I worked on a mobile easel (see page 12), which allows me to move the board freely even when it is heavy with sand, shells, and water. I brushed a little sand over the paper, sprayed on water, and tipped the board. While the sand was still damp, I sprayed on burnt sienna, indigo, and rhodamine inks. After brushing off the dry sand, I highlighted some areas with white ink.

Working with Filaments and Fibers

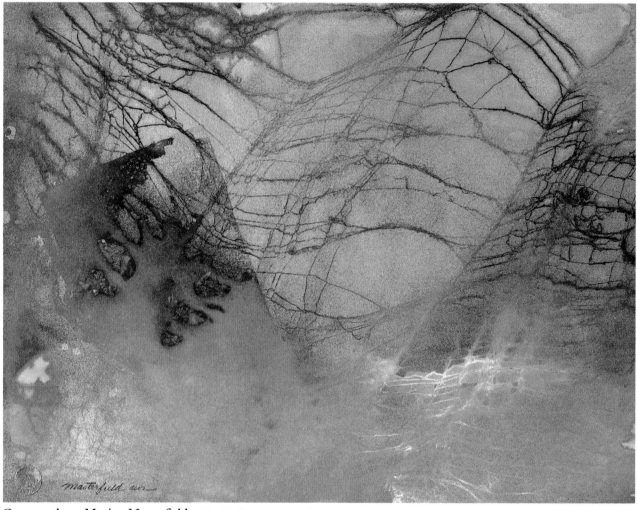

GOLDEN AGE, Maxine Masterfield. *32" x 40" (81 cm x 102 cm), inks and metallic paint on Aquarius II paper. Private collection.*

For Golden Age *I began with the basic fiber method, using a very open cheesecloth of barely connected threads. The geometric shape was cut out of Japanese rice paper, and air bubbles trapped below it gave the appearance of holes. I later decided to enhance the original colors by spraying on gold metallic paint.*

I was once a weaver. There is something sensuous about the feeling of different fibers and the threads spun from them. There is the promise of endless possibilities, from coarse hemp to finest silk. But I was too impatient to enjoy the preparations of setting up the loom and working the endless hours it took for the patterns to emerge from warp and weft. Painting is much more suited to my nature—but fibers still inspire me.

Nothing unifies a design more than a tracing of connecting lines that form their own textured pattern. In the early phases of establishing a design, when loose threads or interesting tangles seem to form drawings of their own, I often find inspiration to continue the subject by adding more defining lines, much like reading in meaning to cracks in walls. It has long been a printer's trick to use fabrics and lace as background textures, instead of drawing in a background. But I prefer less uniform, more open weaves.

Ferns, leaves with prominent veining, and even mosses provide a painting with an intricate quality. But the most versatile source of lines has always been fibers and woven threads. I am particularly fascinated by the line quality of threads that were woven and are then pulled out, retaining a kinky texture. For use with poured inks and watercolors, I have come to prefer gauze and cheesecloth, which are easily pulled apart and made to "run" interestingly. However, any fabric works well if it can be unwoven or have threads pulled out from it.

Fibrous materials can act as resists to shield part of a painting's surface from color. In this sense they function just like any other object I use in my experimental painting techniques. But fibers can also absorb color and hold it next to the paper, or even carry it like a wick away from where it was applied. Working with fibers can yield stark clear lines or pale lines edged by feathered color, single or multiple layers of delicate patterns. I know you will enjoy experimenting with these materials.

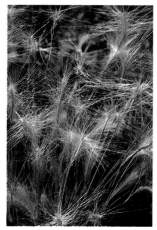

WILD GRASS. Photograph by Howard F. Stirn.

This wild grass is crowned with exuberant bursts of soft, lustrous fibers that extend in every direction. Throughout nature there are narrow filaments, stems, fibers, and fissures that suggest line.

Basic Techniques

Materials

Papers: Aquarius II, Rives BFK, Arches cold-pressed (it is important to use the smooth side of the paper)

Air mist bottles (one for each color and one for water)

FW colored and Rotring inks

Liquid watercolors

Baster or pipette for adding and removing liquid

Cheesecloth and gauze

Plastic window screening

Netting and lace

Plastic needlepoint screen

Hooked-rug backing

Open-weave fabrics

String and threads

Grasses, moss, and other natural fibers

Preparing the Materials:

Whether you are using cheesecloth, gauze, nylon stockings, or any other woven materials, first be sure that they are clean of any contaminants (such as bleach or detergent) and not coated with anything water-resistant, such as oil, starch, or waterproofing. If you are going to use threads that shrink and react to water, test them out first so you know what to expect; some rayons bunch up when wet.

Pull and run the material by cutting it open and laying it flat. (Some materials, such as stockings, start out as tubes.) Unhook the top and bottom threads before pulling to unravel, making the size weave you need for the design. You will probably want some large open areas, and some holes of varied size if your plan includes placing objects with the fibers. The more you unweave the fabric, the more interesting the patterns become, and the more they read like lines rather than fabric on the finished painting.

To complement your fibers, choose objects with a definite open design, not just a solid shape. When using leaves, cocoons, seed pods, weed tops, feathers, or any other kind of natural fiber, be sure it is pliable enough not to crumble or crack apart before giving a sharp image. Some fibers dry quickly, so you may want to use them as soon as you get them, or keep them moist. (If they curl up and the edges do not maintain contact with the paper, you will lose that part of the design.) Threads, even crinkled ones, will weigh down with the ink or paint you add to the painting.

Preparing the Paper

Stretch the paper flat, smooth side up, and staple it to a flat board that can be moved (in case you want to dry it in the sun). If you use a solar box (see page 80), be careful not to add more water or ink than you want, because it will stand in puddles or wash back in low areas. Wet the entire surface of the paper slightly, which prepares it to absorb the color evenly. There should not be puddles or dry spots.

Setting the Design

Arrange the materials you are planning to use in the opposite order from how you want them to appear in the finished work. (Objects that will appear in front of the fiber lines must be put down first, and objects to appear behind the fibers must be set on top of them.) For objects placed in open areas, stretch the pulled fabric first, make the holes where you want them, and then fill them according to your plan.

When the materials in your design are in place, mist the fibers with water to prevent them from moving once the color is applied. If they move before the painting is dry, they may smear some of your image lines.

Applying Color

Before starting to spray your colors, remove any objects that are *on top of* the fiber design; you can easily replace them now that you know where they will go. (Any objects you placed *under* the fibers should stay down, and will leave white shapes in the finished painting.) Spray on your first layer of color, which will set the fiber lines and leave color under the top layer of objects. Then replace those objects, and go on applying color.

Begin with the lightest color you intend to use, and work your way to the darkest color.

Remember that some of the colors will appear darker when they mix, so save the contrast until it's really needed. Spray the color sparingly at first so that you have better control. It is best to spray in the direction of the fibers, so that the color flows with them. Wherever you have enough color but it is not flowing properly, add a fine spray of water.

Controlling the Effects

Experiment with different cheesecloths; some are cotton, some nylon. You may prefer the less absorbent synthetics to cotton gauze.

The absorbency of the fibers you use, the amount of water used with the color, and the speed at which you dry your painting will determine the line qualities of your painting. If the threads attract the color and hold it until it dries, there will be a strong color line. If the threads were already saturated with water or weak color before the strong color reached them, they will resist the later color and shield the paper below them from that color. This will give the appearance of a light line edged by some feathered color. Wherever a puddle of wet pigment covers the paper between the filaments and dries on stages, there is a feathering effect that makes the filament lines less distinct.

If you have built up several different color areas where the wet colors are being separated by threads of your fabric, don't move the board until it is dry, and don't use fans or blow dryers because they can move the liquid. A heat lamp or the sun will dry the painting more quickly without disturbing the ink puddles, but heat evaporation also tends to leave concentric rings of color in large open areas. You may like this effect, but if that is not what you are looking for, the best bet is to go easy on the amount of liquid in the first place—especially the water.

If you already have too much liquid and you don't want the effects of long drying or heat drying, you can carefully siphon off excess water from different areas with a baster or pipette. But do it all at once as soon as you are through spraying, or you will not get an even coverage of color in that area. You can also add color or water to a small area by dripping it on with a baster or pipette.

If you see that the piece is drying too light, you can add more color. If it is too dark, let it dry first, then spray some light opaque inks or metallic paints. (I wear a protective mask whenever I work with metallics.) Unless you deliberately want to lose an object's shape or the pattern of the threads, leave everything in contact with the painting until you are completely finished spraying the final coat.

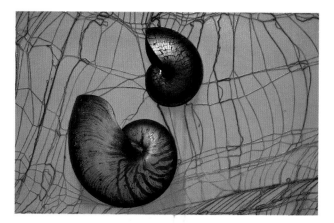

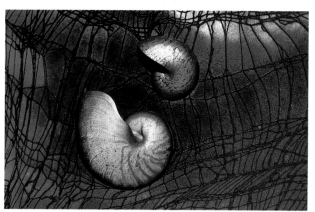

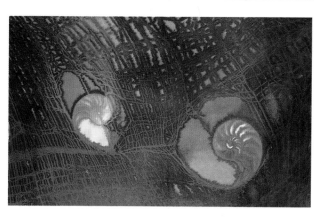

First I stretched prepared cheesecloth over the smooth side of white watercolor paper. I then set sliced shells, flat side down, between or on top of the fibers. To set the design in place, I misted it with water.

Next I sprayed on color, and more water wherever the color was too dense or not flowing well. When the painting was completely dry, I removed the shells and fabric, leaving the strong shell patterns visible at left.

Composing with an Open Weave

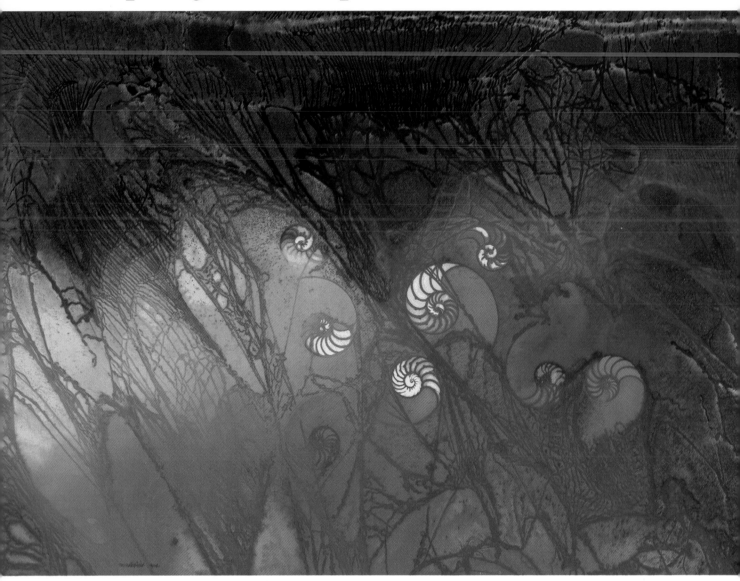

ANOTHER HABITAT, Maxine Masterfield. *34" x 48" (86 cm x 122 cm), inks on Arches cold-pressed paper. Collection of the artist.*

Living under the tangle of "sea nets," where light filters down in deep, exaggerated colors, are small and perfect inhabited shells. The ocean is teeming with activity and life forms, wonders that we seldom get to see.

For this painting I opened up cheesecloth to long, thin strands and placed it over stretched paper. I then tucked some sliced shells into the open areas of the cloth, and slowly poured a bucket of water over it. The flowing water carried the filaments into a natural composition, which I allowed to dry until it was just slightly damp.

I then sprayed on orange, red, turquoise, and lavender inks. The color was absorbed by the fibers and also traveled under the shells, outlining the walls inside them.

Composing with a Fine Weave

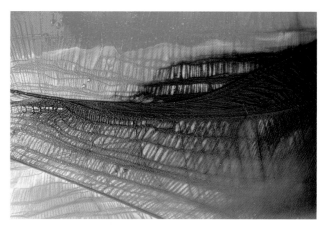

For finer lines, "run" nylon stockings and stretch them in layers. (Three layers are shown here.) Mist or staple the ends of the fibers to hold them in place, and spray your design first with water, then with color.

Add more colors from light to dark, and leave the painting to dry completely.

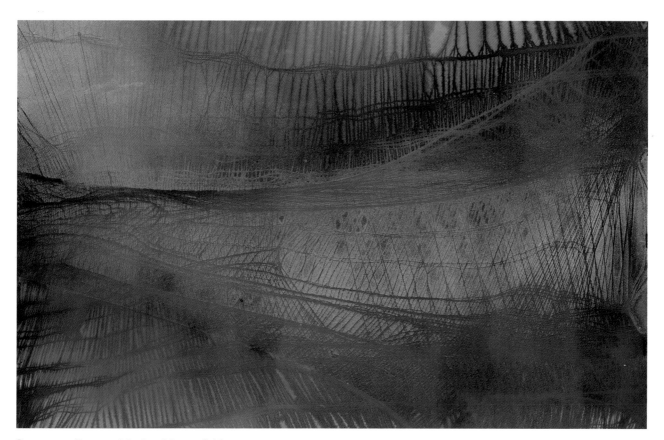

CLEARING DAWN, Maxine Masterfield. *20" x 30" (51 cm x 76 cm), inks and metallic paint on Arches cold-pressed paper. Collection of the artist.*

In this instance, when the inks and paper were completely dry, but before removing the stapled weave, I sprayed gold paint through the weave in selected places, preserving the color pattern of the weave lines.

Creating Lace Patterns

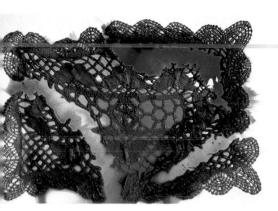

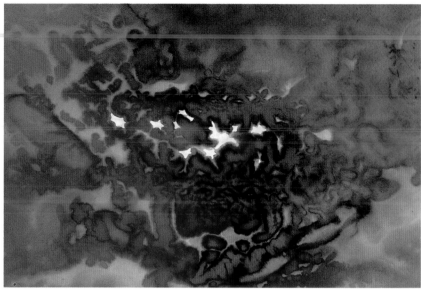

FLOWER CENTERS, Maxine Masterfield. *21" x 30" (53 cm x 76 cm), inks on Dippity Dye paper. Private collection.*

Begin by setting lace down over stretched watercolor paper (above). Spray water and then inks over the surface, cover it with thin absorbent paper, and let it dry. Both sheets will pick up images from this process.

Flower Centers *is the top sheet. Notice that it has picked up color where it made contact with the ink-sprayed lace, and remained white where the lace held it away from the wet paper.*

Heart Fragments *is the bottom sheet that goes with* Flower Centers. *Because the lace was in direct contact with it, this sheet of paper picked up greater detail than the top one. I sprayed gold through a heart template and outlined some of the shapes with gold.*

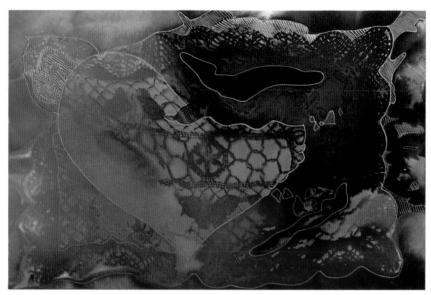

HEART FRAGMENTS, Maxine Masterfield. *20" x 30" (51 cm x 76 cm), inks and metallic paint on Arches cold-pressed paper. Private collection.*

Further Advice on Working with Filaments and Fibers

When your piece is completely dry, you can remove the fabric and objects and see if you are satisfied. The work may be almost complete in itself, with just a few touches needed for definition. Of course some artists just use the line patterning as inspiration to suggest a subject for which the lines become merely a background texture.

If you think the colors and design are altogether too weak to use, you can start all over again and cover it all up.

You can also cut out the best areas to use for collage, or weave the piece together with a contrasting one (see pages 98–113).

Another solution for very pale fiber paintings is to cover with shapes any areas you wish to preserve, and stretch some new fibers across your design. Then spray with opaque or metallic paints. The areas shielded by the new fibers will remain the pale colors of the original painting. If you choose new colors that contrast well, a bland piece can be transformed into a highly appealing one.

When a painting turns out too dark or unfocused, design another layer of fiber lines and objects to complement it. This approach works best *before* you remove the original fabric and objects. Leave everything down to preserve the initial pattern, and cover some or all of your painting with new fibers and shapes. Then apply a light opaque or metallic spray. When it is dry, look carefully again before removing anything. You may want yet another layer, even if just in a small area or two. In the finished piece, each successive layer of lines will appear as if behind the previous one. If you have worked from light to dark through all your layers, there will be a pleasing sense of dimension to your work.

There are more experimental and messy ways of working with fabric that you may want to try. One is to saturate the fabric with color either before (really messy) or after it is placed on the prepared surface of the paper. This ensures that the color will penetrate the fabric and show a sharp linear pattern. Once the line color is well set, opaque or darker sprays of color can cover up any drips or smears that are not wanted. Do not move the fabric until the painting is dry and finished.

With this method too, a second layer of fiber pattern can be added. Just remember that the open or unpatterned sections will give you what you see, so be sure you like that last layer of colors you put down.

Evoking the Feeling of Frost and Ice

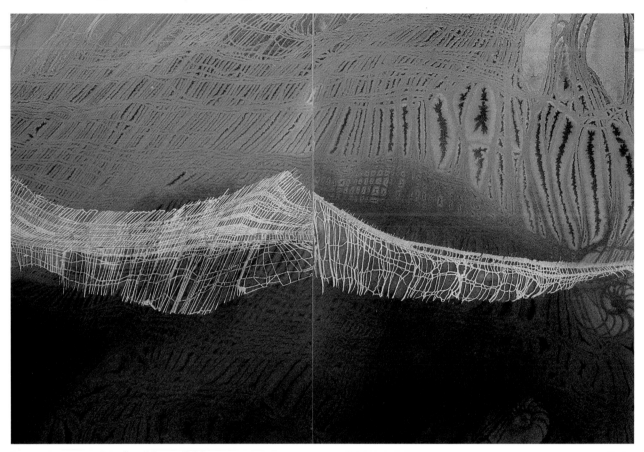

FROST LATTICE, Maxine Masterfield. *Diptych, total size 30" x 43" (76 cm x 109 cm), mixed media on Aquarius II paper. Private collection.*

The finished illusion is that of peering through layers of winter-frosted glass at a chilly world. Ahead is the thaw, when ice-choked rivers will begin to flow again.

I stretched two sheets of paper side by side, and covered them with overlapping layers of pulled gauze across the whole width of the sheets. As I sprayed the colors, I tried to keep the mood mellow. When the inks dried, there was so much soft feathering of the filament lines that it reminded me of the frost that coated the windows during my Ohio winters. I loved the thought, but felt that I needed to give the image more contrast and power—yet without losing the feeling of crisp cold (from the vantage point of being safe and warm inside). It was then that I decided to add more gauze to the painting with its punch of pure white.

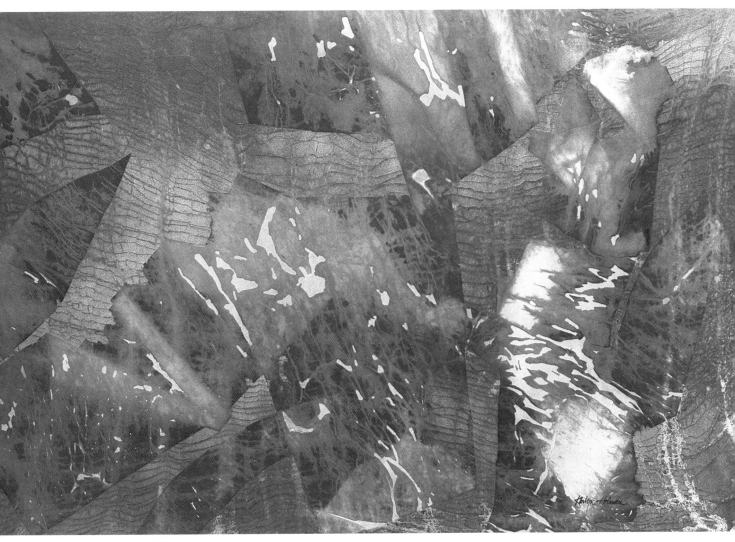

Ice Forms, Karlyn Holman. *19¼" x 30" (49 cm x 76 cm), inks and metallic paint on Crescent board. Collection of the artist.*

"I've always been fascinated by combining transparent and opaque in a composition, such as gold paint in combination with transparent, permanent inks.

"I like to work with some control and a lot left to chance. For this painting I decided to use waxed paper because it would give me a somewhat controlled expression of white patterns, and because it would either act as a resist or wick the wet ink under the cut forms. I placed cut waxed-paper shapes onto the wet board, then poured water over them and watched as they moved about as though they had a will of their own. (Letting the water move the shapes seemed so natural.) I then sprayed colored inks over the surface. While the ink was still wet, I stretched cheesecloth over the waxed paper and ink. As a grand finale, I sprayed metallic gold in selective areas. The real excitement came later when I pulled off the pattern makers and exposed the fluid shapes below."

Layering to Create a Sense of Space and Dimension

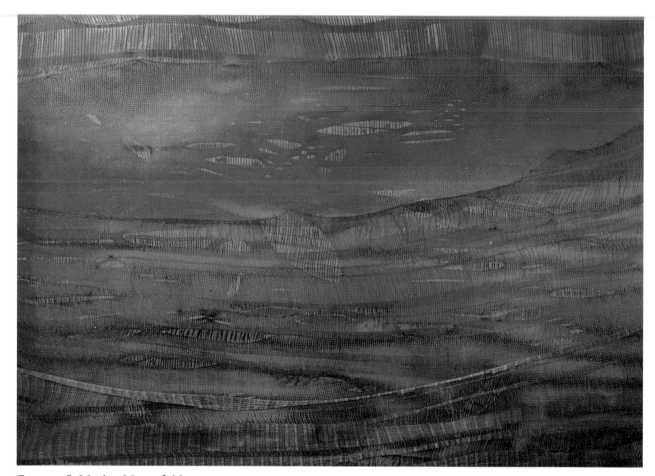

GENESIS I, Maxine Masterfield. *42" x 60" (107 cm x 152 cm), mixed media on Aquarius paper. Collection of Vicki Anderson-Shore.*

This painting is about the first day of creation: the coming of light and the promise of substance to follow, with colors hinting at nature as it would eventually be. Without revealing any recognizable life form, I wanted to convey the possibility of green foliage, blue seas and sky, and glorious red sunsets, with subtle color transitions between them.

Fabric provided just the combination of order and ambiguity I needed. Many layers of punctured cheesecloth were stretched to give the painting a sense of depth. Three of the layers of cloth used to stain the paper were later adhered to the foreground for further dimension. The golden veils remind me of waves of reflected sunlight.

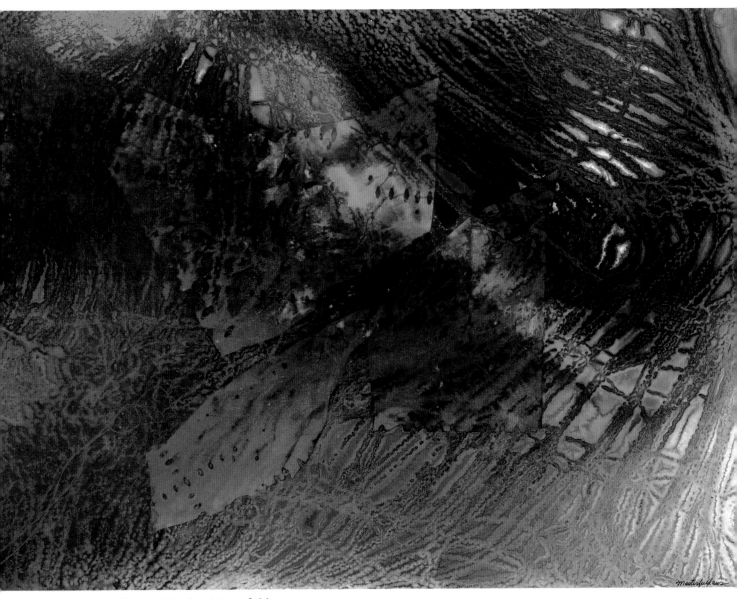

DIAPHANOUS FORMS, Maxine Masterfield. *22¾″ x 30″ (58 cm x 76 cm), inks on Aquarius II paper. Collection of the artist.*

Before begining the basic fiber technique, I set down four straight-edged pieces of tissue paper. It is hard to distinguish whether the resulting ghostlike forms are floating in front of or behind the webbed, multilayered atmosphere. The line quality of the webbing is very feathered and seems like disconnected particles—almost like iron filings attracted by a magnet. The blazing streak of bright red forms yet another layer between us and the white light that is barely evident through these translucent membranes.

Exploring Reflections and Backlighting

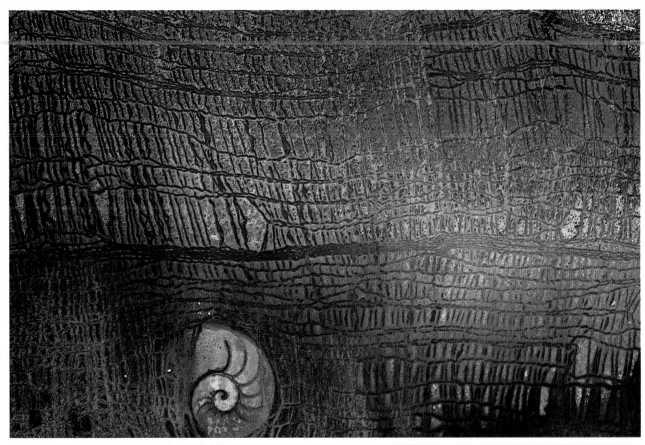

SECRET PASSAGES, Maxine Masterfield. *30" x 40" (76 cm x 102 cm), watercolors on Whatman watercolor paper. Private collection.*

In Secret Passages, *the sunlight filters through the curtained air, backlighting each strand's feathered edges.* Reflected World *shows mountain peaks reflected along with brilliant sunlight through delicate blades of grass on a water surface. In both cases a linear mask comes between us and the full strength of the sun. When fiber lines are darker than the color around them, it creates an effect similar to backlighting.*

For Secret Passages, *I placed the sliced nautilus shell down first, and covered it with opened cheesecloth. Some of the color traveled under the shell, registering the shapes of its chamber walls.*

REFLECTED WORLD. Photograph by Howard F. Stirn.

Finding Figurative Possibilities

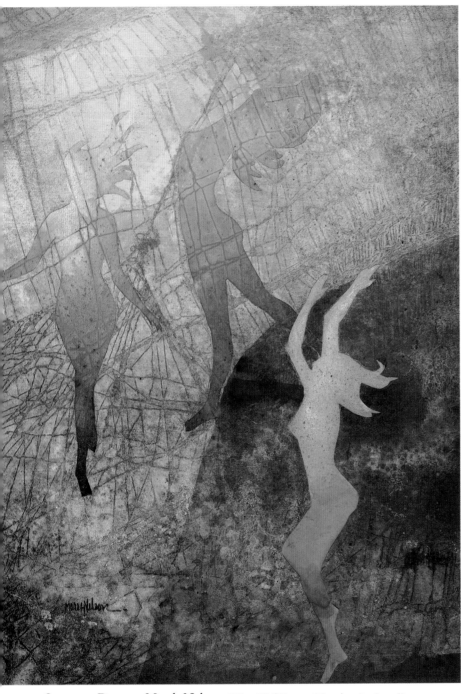

SHADOW DANCE, Marsh Nelson. *20" x 15" (51 cm x 38 cm), mixed media on Crescent board. Collection of Linda Craker.*

"I did 32 paintings that I called my Dream Net Series. I often do dream paintings because the subject has captured my imagination for years. The delicate, ethereal patterns created with gauze and inks are a perfect vehicle for dreamlike subject matter.

"Some of the paintings, including this one, had to be planned in layers. For Shadow Dance, a graduated watercolor wash of gamboge was brushed onto the board. I had cut figures of thin rice paper to use as stencils in another painting. The colors were so interesting that I decided to collage them onto this painting. I glued the top two figures onto the board and stretched cheesecloth over it. I then poured ink and washed on darker gray watercolor in the lower right. The third, lower figure was collaged on last."

Capturing Nature's Luminous Effects

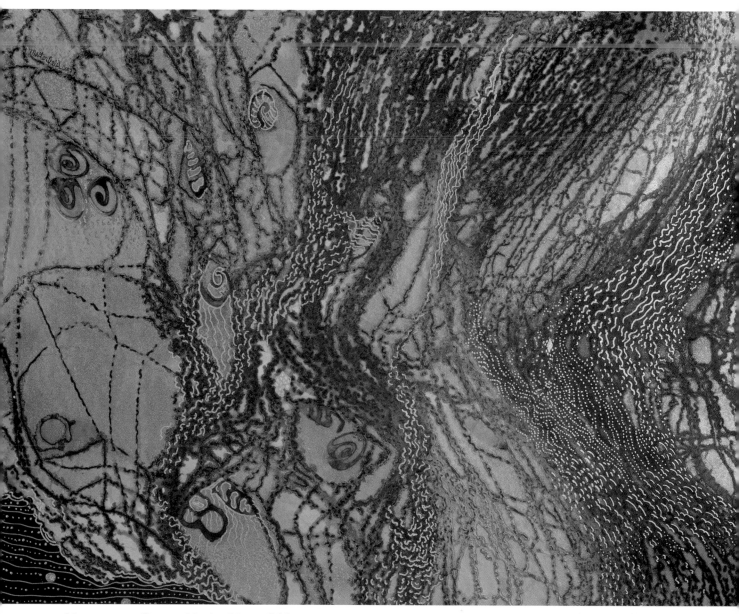

MOONLIGHT CATCH, Maxine Masterfield. *31½" x 40" (80 cm x 102 cm), inks on Arches cold-pressed paper. Collection of Bonnie Christensen.*

The detail and energy of this painting reminds me of the tiny creatures that purify the water and at the same time feed small fish. Sometimes they are luminous and give an eerie glow to waves crashing on the beach at night.

I varied the basic steps of the fabric method by opening up cheesecloth until it became a tangle of wavy string. After the image was captured, I felt a need for more line. With a silver pen I added details to the curvy lines of the threads, being careful to follow the flow of the original pattern.

When the light hits this painting, the silver lines reflect back, just as I imagine the creatures in the filtered moonlight would.

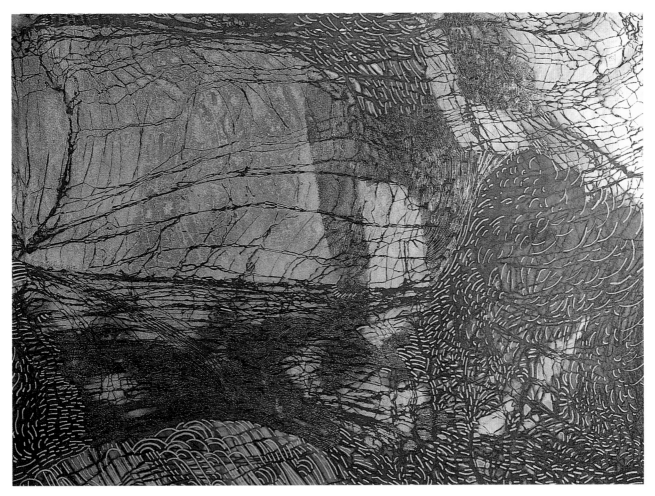

SATELLITE IMAGE, Maxine Masterfield. *30″ x 40″ (76 cm x 102 cm), inks and metallic paint on Arches cold-pressed paper. Private collection.*

I imagine that the earth would be an inspiring view from a satellite. At different times of day, the light would gleam and shimmer off lakes and winding rivers, drawing golden strands and curving lines. The atmosphere with its climate changes and haze would distort the earth's surface into vivid patches of color. On a smaller scale, the dew-laden spider web in the photograph has that same quality of hovering in the air on its own.

I began Satellite Image *with light washes of blue and lavender over watercolor paper. Then I put large shapes of rice paper and opened cheesecloth into the color. When the color dried, I took the painting outside and sprayed metallic paint over the shapes and fabric. I felt that the image still needed more definition, so I added lines with metallic gold in some of the open, unlined areas.*

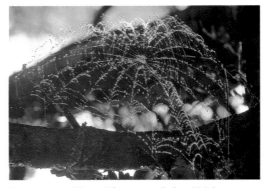

GLEAMING WEB. Photograph by Shirley Hummel.

Crystal Forms

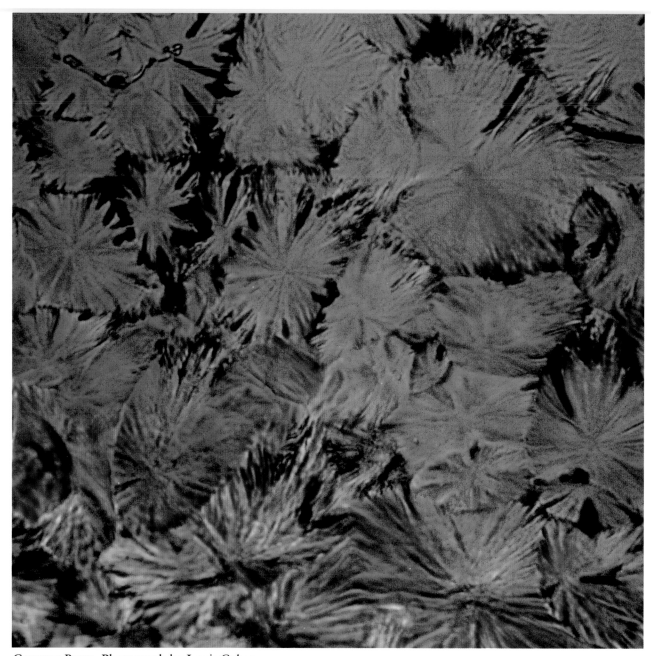

CRYSTAL BLUE. Photograph by Louis Cohen.

As an alum solution dries, it forms radial crystals that look very much like frost. Polarized filters then give a color range to the crystals, depending on their thickness.

Where I go rock-hunting for crystallized calcite in upper Florida, I've seen large sections of boulders left from commercial mining, exposed and glimmering in the sunlight. Brilliant yellows, golds, and light blues sparkle amidst a dusty gray world. I love to break pieces off and take them back to my studio for inspiration. There I study them not only for form and structure, but to understand the interplay of light and density that defines them.

Some crystals are translucent, while others are reflective. Each kind of crystal has its own characteristic number of sides. But crystals of all kinds have natural flat planes. Their slick surfaces and straight edges contrast with the many textures and rounded or amorphous shapes elsewhere in nature. The way crystals can both absorb and reflect light and color is even more visually exciting. When individual crystals are separating from a large mass, the light permeates them and they are almost white. But when crystals are joined and almost impenetrable, they glow with deep rich color when light is focused on them. Examining crystals under a microscope and through filters will open a whole new world of visual possibilities for any artist.

I have done a number of paintings inspired by crystals. Sometimes I work toward the soft, luminous quality of separating crystals, bringing out the straight edges but achieving a diffused look by using high-key colors. In other paintings I seek the high contrast found in reflections off dark opaque crystals, where there is a mirror effect.

Many techniques can be used to paint crystal forms. Torn or cut paper yields clean, sharp edges; folded rice paper can be used to create subtle layers of color. Some paintings shown here were done using splattering techniques, cheesecloth and other fabrics, and collage. Diverse though these approaches may seem, they are all attempts to portray one of nature's most magical forms of beauty.

Basic Techniques

Materials

Smooth watercolor paper, such as Aquarius II or Rives BFK

Paper for cut shapes and folding: white tissue paper, Japanese rice papers, Dippity Dye paper (an absorbent paper made for calligraphy and tie-dying)

Watercolor inks

Liquid and tube watercolors

Spray bottles for water, watercolors, and inks

Soft brushes that won't tear wet tissue

Velverette glue for collaging

Solar box to retain water while painting

My basic technique for crystal paintings involves several steps. First cut out straight-edged shapes from lightweight paper, place them on a wet sheet of watercolor paper in whatever design appeals to you, and mist them with more water. (The water adheres the cutout shapes to the painting surface, and will also help the color to flow.) Then spray on color, from light to dark. The color will be trapped under the cutout shapes so that the watercolor paper absorbs it. When the painting is almost dry, remove the shapes. Some of them can be collaged back onto the painting after it has dried completely.

Paper

Smooth watercolor paper is ideal for this method. Most kinds must be stretched and fastened down to a board; however, some papers (such as Rives BFK and Aquarius II) have enough body not to curl when wet. Such papers can be placed in a large shallow pan (see description of solar box on page 80) so that the sides will keep the water and color from spilling off the edges. Some printmaking papers with smooth surfaces also make a good surface for the finished painting.

Use light, porous papers for the crystal shapes. Tissue paper holds a lot of color in place on the painting because it cannot absorb much color itself. Fine, light rice papers, both smooth and textured, leave interesting impressions.

Dippity Dye paper absorbs a great deal of color and therefore will preserve light-to-white areas best. The Dippity Dye paper is also the strongest, even when wet, and retains the brightest color for use in collaging.

Composition

Wrinkles in the tissue paper will create a line texture. Bubbles will register as light areas if the air keeps the color away, or dark areas if they trap a puddle of color. Remember that the lighter-weight tissue allows the most color to penetrate, so use the heavier paper for the shapes that you want to come out palest when the painting is finished.

If you want a complex composition with several layers of shapes, you can add more cutout shapes after the first layer has soaked up color and stained the painting surface below. Put the new layer on top of the old, mist it with water, and spray on color as before. Bear in mind that the first layer of shapes will appear to be in front in the finished composition.

Color

It is best to spray on your colors from light to dark because the dark colors will show up through the light ones far better than vice versa. Gauge the strength of your colors by how vivid you want the final result to be and by how much water you have sprayed onto the surface; more water requires more color. White can be very effective in open areas to set the colored shapes apart.

Drying and Collaging

The drying time will vary depending on the amount of liquid, the number of layers of paper shapes, and whether you dry the painting in the sun or indoors. Remove any tissue shapes before they are completely dry, or they will stick to the surface permanently. Tissue paper usually tears as you remove it, but with care you can remove the heavier paper shapes intact and collage them back on once the painting is dry. I have found Velverette glue to be the best for collaging paper and other materials.

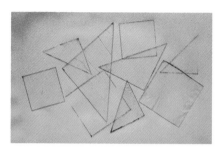 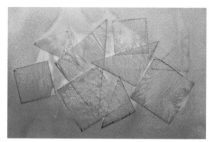 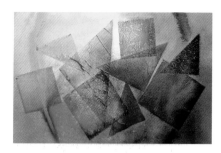

Cut shapes out of white, lightweight paper. Place them on a sheet of wet watercolor paper and mist them with more water. (In this example some of the shapes are cut from tissue paper, others from patterned Japanese rice paper.)

Spray on color from light to dark, fixing the shapes.

Leave the shapes in place until the colors are almost *dry*. (Don't wait until they stick to the surface!)

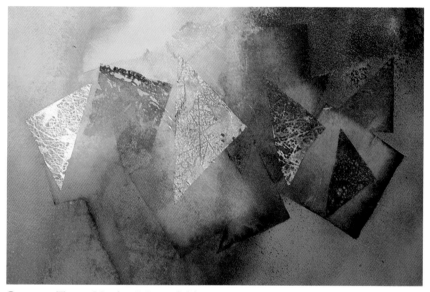

After removing the paper shapes, I collaged some of them onto the painting. Rice paper works better for this than tissue paper because it is not quite so fragile.

CRYSTAL TIDE, Maxine Masterfield. *21⅞" x 32" (56 cm x 81 cm), inks and collage on Rives BFK paper. Collection of the artist.*

Creating Crystal Forms with Folded Paper

This technique works best in a pan with sides, such as the solar box described on page 80. You should start working in a place where the pan of liquid can dry slowly and undisturbed. Begin by folding a heavy rice paper in whatever simple or intricate fashion you like; horizontal folds work well, especially if spaced out so that not too many layers overlap. Set the folded paper into a pan with sides and place cut shapes of lighter paper over it. Then pour generous amounts of water over the surface, being sure the paper is evenly wet. There should be some water floating on top.

Use air mist bottles to spray colors onto the floating water. It is important not to move the pan until all the water has evaporated! Keeping opposite ends of the spectrum in separate areas of the water is usually most successful. Be sure you have enough color to penetrate into the paper, remembering that the layers the color reaches first will absorb the most. So will the edges of folds. The paper shapes will partially shield the area underneath them, so that the color will be fainter there.

While the painting is still damp, you can move some of the top shapes and add more colors. (Here the three paper triangles have been turned upside down.) Then leave the painting to dry. Because tissue will glue itself to the painting surface if left to dry completely, be sure to remove it while the painting is still slightly damp—and don't leave the pan unattended in the sun. Unfold the finished painting and flatten it out using one of the methods described on page 80.

RHYTHMS IN SPACE, Maxine Masterfield. *22" x 30" (56 cm x 76 cm), inks and collage on heavy rice paper. Collection of the artist.*

When I unfolded the paper to see the design, I felt that it needed some deeper color and definition at the bottom to offset the light horizontal bars that were the inside folds. I collaged on the pyramid shapes in the same color order they had been throughout the process.

Capturing the Translucent Quality
of Quartz Crystals

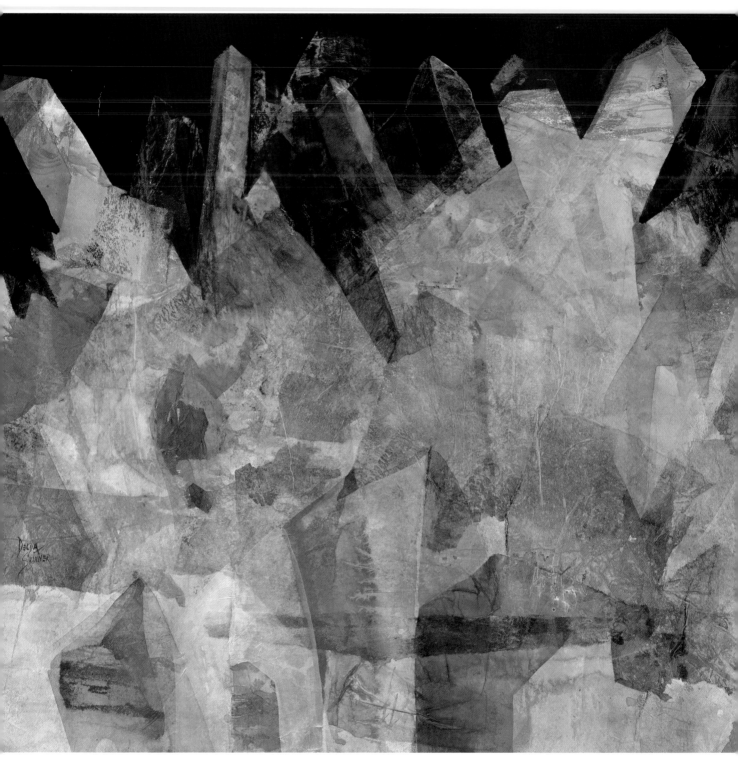

NEXUS, Delda Skinner. *19" x 28" (48 cm x 71 cm), acrylics and collage on bristol board. Private collection.*

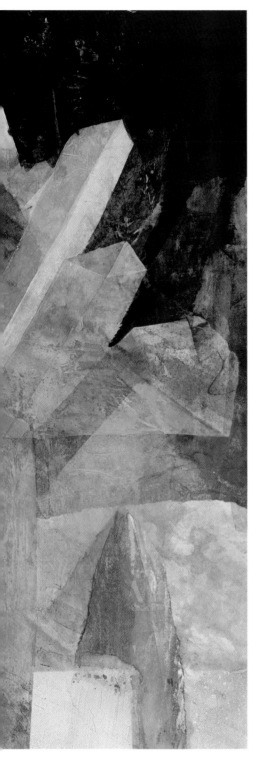

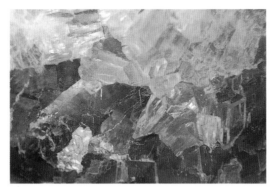

CRYSTALS WITHIN A GEODE.
Photograph by Maxine Masterfield.

"The driving force behind my crystal paintings is the unparalled beauty of all crystals, which has always intrigued me. Their uniqueness is a quality that I associate with all of life. Even though all crystals of the same substance are similar in shape, they are diverse in almost every other way.

"I usually start a painting with an idea in mind (in this case, crystals) but without any preconceived visualization of the end result. I like to leave all my options open to take advantage of unexpected occurrences involving color, line, shape, or texture.

"For Nexus I partially wet my board using a large brush and applied a random acrylic wash, mixing the colors on the surface as I painted. I added texture by splattering paint, alcohol, and clear water into the wash of color, and let it dry.

"I then used matte medium to collage on torn or cut shapes of white tissue and rice papers (Unryu, Suzuki, and Kozo Light), some of them prepainted. The collaged pieces also had to dry because the color showing through them looks entirely different when they are wet. I then applied another wash, watching edges and how the colors reacted with the layers of paper.

"Nexus has about four layers of papers with washes of color in between. The finishing touches were the white acrylic to give more definition to some crystals and the dark background to add depth and mystery."

Interpreting Reflections from Opaque Crystals

Imitating Crystal. Photograph by Howard F. Stirn.

In Crystal Reflections *I wanted to capture the look of dark, opaque crystals, which are full of stark contrasts. Depending on the angle from which you look at such crystals, some facets appear very dark while others reflect their surrounding in high-key colors. The contrasting colors and straight-edged forms make for fascinating patterns.*

The photograph shown here, Imitating Crystal, *reveals a similar effect, but with more curvilinear edges. Crumpled gold foil was photographed through a rainbow filter. Light and color were reflected only by those facets that were parallel to the light source, leaving the shadowed planes dark and mysterious.*

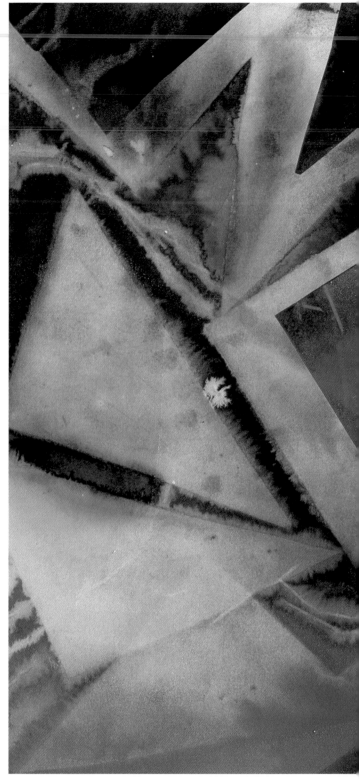

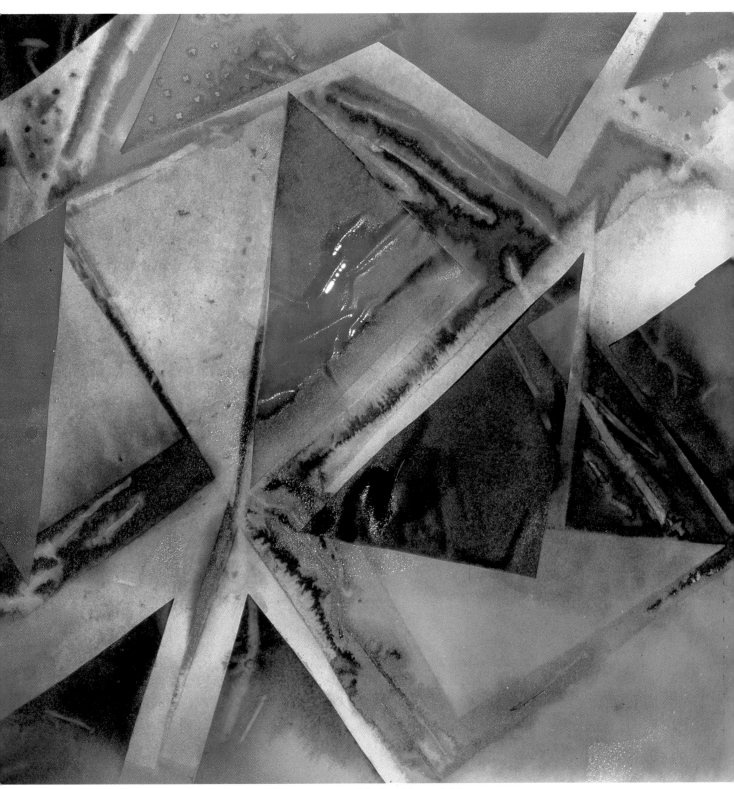

CRYSTAL REFLECTIONS, Maxine Masterfield. *18" x 30" (46 cm x 76 cm), inks on hot-pressed paper. Collection of the artist.*

Expressing Buried Energy

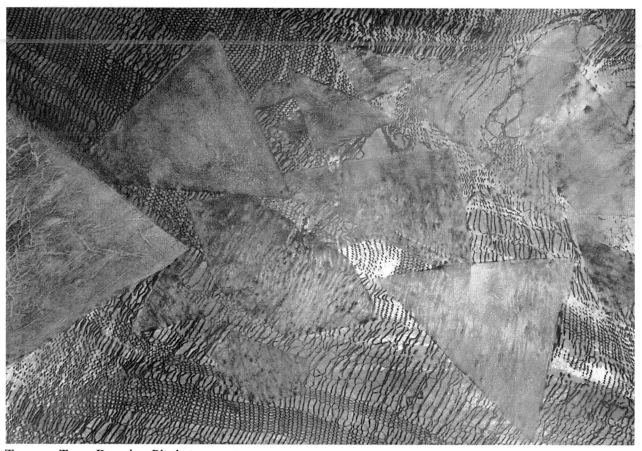

TRAPPED TIME, Dorothea Bluck. *22" x 30" (56 cm x 76 cm), inks and gouache on Arches hot-pressed board. Private collection.*

"Trapped within our living earth are beautiful quartz crystals that transmit and receive cosmic energy. As I worked on Trapped Time, *I thought of that energy.*

"I flooded the watercolor board with a light wash of indigo and antelope inks. Because I wanted straight, sharp edges, I cut shapes of crystals from waxed paper and laid them into the wash of color in an overlapping design. Over them I then stretched loosely woven cheesecloth, which I had torn and pulled apart to create the web. Inks of indigo, antelope, and rhodamine were then poured and brushed over the entire painting, and it was left to dry overnight. When I removed the cheesecloth and waxed-paper shapes, my crystal shapes were trapped within a mythical net of time. I enhanced some areas of the design by brushing on pearl copper gouache."

TIME WARP. Photograph by Louis Cohen.

Crystalized naphthalene was pulled into jagged layers of color on this magnified and polarized microscope slide.

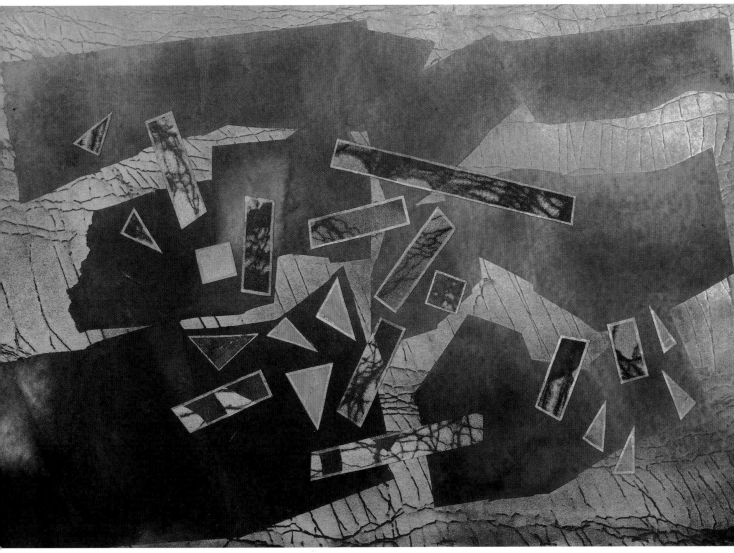

FLOATING CRYSTALS, Maxine Masterfield. *18" x 25" (46 cm x 64 cm), mixed media on hot-pressed paper. Private collection.*

This painting reminds me of crystal fragments floating through space, with the larger shapes as their echoes or shadows. First I sprayed color over stretched paper, and then set in folded layers of tissue. Before the ink was dry, I stretched opened fabric over the surface and sprayed gold paint over it.

Once the paint was dry and the waxed paper and tissue were removed, I cut rectangular and triangular shapes from several discarded paintings that had lively colors but some similar feel to their textures. I collaged them onto the surface in a scattered design. Before gluing them down, I outlined the forms in gold with a drawing pen, to give them a separateness and stiffness in contrast to the light, filmy quality of the rest of the painting.

Creating a Sense of Depth

Although I usually work in two dimensions, I often try to create the illusion of more depth. To make one thing appear to be nearer while something else lurks beyond is sleight of hand for the artist; it is creating a spatial mirage.

With Crystal Fragments, I lifted shapes cut from Japanese leaf-patterned paper and collaged them onto other places. The light areas they vacated appear to be floating some distance in front of the less defined background, partly because of the open pattern in the paper. The collaged pieces with their darker coloring form another layer in space.

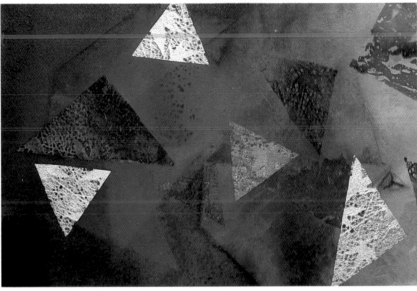

CRYSTAL FRAGMENTS, Maxine Masterfield. 21½" x 30" (55 cm x 76 cm), inks and collage on Aquarius II paper. Collection of the artist.

"The inspiration for Crystal Galaxy was slides of crystals taken under a microscope. I arranged triangles of tissue paper on wet rice paper with many overlaps and size changes to give a feeling of dimension. The round shape in the upper right was done by spraying paint over an embroidery hoop, and a run nylon stocking was used for the texture of the orange streak. When the inks I sprayed were dry, I peeled the triangles off and collaged them onto other areas, compounding the illusion of multiple overlapping layers floating in space."

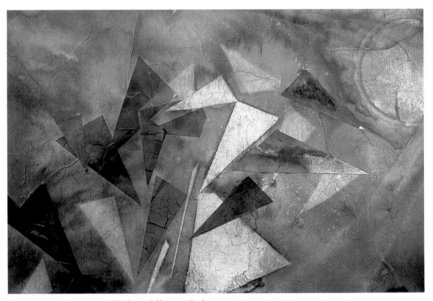

CRYSTAL GALAXY, Elaine Albers Cohen. 21½" x 30" (55 cm x 76 cm), mixed media on Japanese rice paper. Private collection.

Exploring Layers of Light, Darkness, and Time

CENTER OF LIFE, Maxine Masterfield. *21½" x 30" (55 cm x 76 cm), inks on Aquarius II paper. Private collection.*

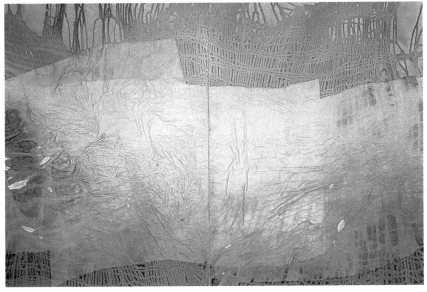

FROM THE PAST, Maxine Masterfield. *Diptych, total size 30" x 40" (76 cm x 102 cm), inks on Aquarius II paper. Collection of Carde Hilde.*

Although both of these paintings use similar color schemes, texture materials, and a horizonal direction, they are meant to give different impressions. The long, narrow folds in one work and the single overlapping thicknesses in the other acted to allow varying degrees of the fabric pattern through.

In Center of Life, *the view was meant to focus on the narrow central crystal and the eerie light shining through it. If you have ever put a crystal or prism close to your eye and attempted to look through it, the light appears as one white slit, with the other colors becoming a fuzzy, darkening blur near the edges of your vision. Here the crystal is portrayed as a symbol for all life: diverse mystical combinations of light, darkness, and matter, but all pulsating and glowing with their own mysterious energy.*

From the Past *represents a symbolic chronicling process. The clear, overlapping sheets of tissue seem to be floating in vaguely from the right and left. The fabric "veils" represent events that permeate the pages to record time. This was a softer, less dramatic piece using little contrast, with light rather than darkness over the horizon.*

Unearthing Mammoth Crystalline Forms

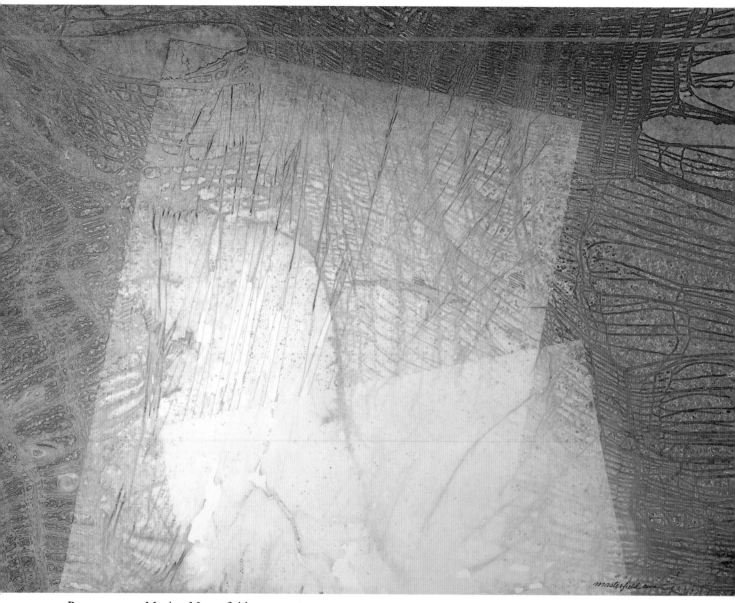

BATHOLITHS, Maxine Masterfield. *32" x 40" (81 cm x 102 cm), inks on watercolor paper. Private collection.*

Batholiths are enormous masses of igneous rock intruded into formations that were already folded and uplifted. They consist of granite and other coarsely crystalline rocks. A Mesozoic batholith in Idaho covers 16,000 square miles. One on the Canadian coast range has an area of about 100,000 square miles!

 My more modest version appeared serendipitously. I placed a large, full sheet of tissue paper, some opened fabric, then more tissue over dampened smooth watercolor paper. Where the tissue was doubled, very little of the color reached the paper surface. The very faint image gave a transparent cast to the large shapes. I then imagined them as huge batholiths of clear crystal embedded in fibrous cracked folds of rock.

Seeing into the Past

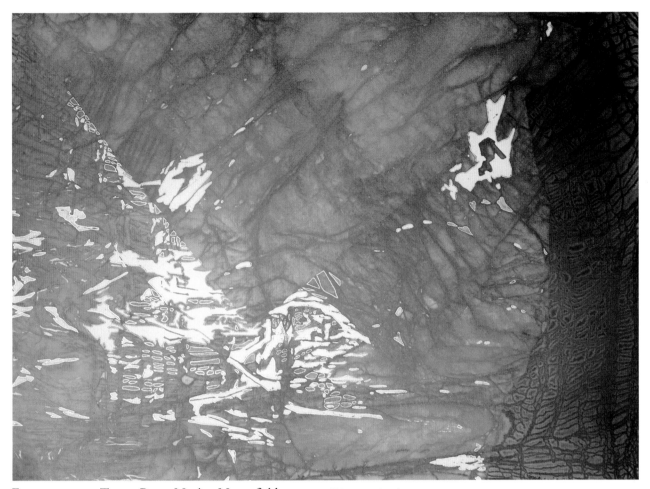

FRAGMENTS OF TIMES PAST, Maxine Masterfield. *22" x 29" (56 cm x 74 cm),*
watercolors and inks on fine Japanese paper. Private collection.

In my favorite fossil pits (which I visit weekly) there are layers and layers
of fossilized shells dating back several million years. They are bone white,
very fragile, and quite often found one inside another. When I put them on
the window ledges in my studio, the light filters through them as if they
were very fine bone china. And if I look at them long enough they begin to
appear transparent.

Fragments of Times Past represents not just the history of this planet
with its time-fractured appearance, but the fragility of things that survive. I
made this painting by placing two large sheets of thin Japanese paper in
a wash of water, watercolor, and ink. The paper rippled, and air bubbles
were trapped inside, forming white areas. I outlined some of them with a
silver pen. To me the white areas hint at places where time has worn
away the material elements, but allowed us to see beyond them into the
past, making our antecedents crystal clear.

Solar Painting

INTO THE NIGHT, Maxine Masterfield. *Diptych, total size 29" x 42"*
(74 cm x 107 cm), inks on Dippity Dye paper. Collection of Ina May Moore.

Into the Night *reminds me irresistibly of bright flames licking away the*
darkness, fed by blue misty gases. When I made this diptych solar
painting, the water and colors were disturbed in the solar box and
appeared to have merged into one black murky wash. I was sure there
would be nothing worth salvaging, and left it to dry. Early the next
morning I went to start the process anew and was thrilled to find that the
evaporating water had uncovered a dramatic and exciting vision.

In nature, water is continually recycled from solid ice or crystallized snow to liquid water to water vapor, depending on the temperature. The heat of the sun is crucial to this process.

On a smaller scale, artists who work with water media are continually adding more water to create a wash or flow, or wishing a painting would dry faster so that the next step can progress. Solar painting is a way of emulating the natural water cycle to accelerate the evaporation process. What inspired me to discover this technique was—believe it or not—a leaky ceiling.

While conducting a workshop at the Oklahoma Fairgrounds one rainy spring, I became interested in the progress of a leaky roof in one of the large rooms. At first there was a large wet ring on the ceiling, saturated and dripping. As the rains left and the week wore on, I found myself glancing up from time to time to watch as the drying ceiling tile produced smaller concentric stained rings. They were interesting and irregular, not unlike the growth rings in trees.

Back home in my studio, I began to experiment with ways to achieve similar effects. I wanted the ability to partially control the effects of pigment in water—the choice of irregular rings, feathered edges, and gradual build-up wherever I wanted it. I also sought a way to create grainy effects by allowing the pigments to pile up on the surface.

The technique I finally developed involves a solar box: a wide, shallow box or pan with sides at least one inch high, in which a painting can be suspended in water and pigment. The solar box is then placed in the sun (or, if that is impossible, you can substitute lamps, heaters, or fans, taking care not to blow them directly at the painting). As the water evaporates, the pigment slowly adheres to the paper, gathering into any wrinkles there like silt on the bottom of a riverbed. The water and colors do not run off, the way they would from a flat board, so no color is wasted.

Retaining the water and pigments over or under the paper is half the battle. The other is controlling the movement of the water so that it doesn't wash together and muddy all the colors. Making sure the work can sit still in a solar box while it dries is important.

No matter what you do, the results of solar painting are unpredictable. When you leave your painting in the sun to dry, you have only the vaguest idea of what it will eventually look like. Yet you do retain some control over the process. A finished solar painting is a sort of collaboration between the artist and the sun, between the planned and the serendipitous.

Basic Techniques

Materials

Solar box or pan with sides at least 1 inch (2½ cm) high; for more detailed description, see below

Light, maleable papers (such as Dippity Dye and Japanese rice papers); both sides are usable

Medium-weight papers that will wrinkle into depressions (such as Rives BFK and Arches)

Dyes and inks that dry permanent, such as FW colored and Rotring

Acrylic and watercolor paints

Spray bottles for water and colors

Pipettes and basters for adding and subtracting water and color

Batik tool for wax line drawing

Paraffin for use alone or with batik tool

Colored crayons for melting and drawing with batik tool (if you like the color, leave it on)

Using the Solar Box

As mentioned earlier, a solar box is some type of shallow pan that will hold water. It must be wider than the painting. For small paintings, a 9″ × 13″ (23 cm × 33 cm) glass baking dish will do; so will a rubber pan meant to hold cat litter. For larger paintings, you may prefer to build your own solar box. Mine is made of a sheet of bathroom wallboard (similar to Formica), with sides of V-shaped plastic about 1 inch (2½ cm) wide that was intended for corners of walls to protect the wallpaper. (Many of my favorite tools were not manufactured with art in mind!) I scored and bent the corner strip to fit the bottom of the box, and adhered it with clear bathroom silicone.

To make a solar painting, you should work wherever the painting will dry, because it's almost impossible to move before it dries. Begin by placing some objects in the bottom of the solar box. Sticks, twigs, and string can be used for linear effects. Wrinkled plastic is excellent for complex patterns of ridges. The objects need not be very thick, but they should lift the paper slightly in some areas.

Now add a sheet of Dippity Dye or rice paper. Spray on water and add color carefully with a pipette or baster. You can then add more objects on top of the paper, and more color or

water under them with your pipette or baster. You should end up with about ⅛ inch (3 mm) of water over the paper.

Evaporating the Water

If the painting dries undisturbed, colors carefully dropped into separate areas of the water will stay separate. Sometimes slowly moving water creates swirling patterns of colors—and the pattern changes dramatically as it dries. As the water evaporates, it gradually pulls away from the paper, causing patterns to form along the contours of the objects in the pan or any wrinkles or depressions in the paper. The sun is your most helpful ally here. It is crucial to leave your solar box in a place where it will not be disturbed.

If you need to resort to forced-air heaters or fans, aim them so that the air movement is a steady stream over and across the work, not directly onto it. Ripples in the water will stir up the settling pigments.

Sometimes a specific area can be quickly lightened or dried with an absorbent towel, tissue, or sponge. I have even let the falling force of a drop of water push the pigment aside as it splashes down, to open some white spots. This must be down while the work is still wet, because the pigment is permanent once it dries.

Flattening the Finished Painting

Solar paintings do not dry flat, but conform to the shape of the objects in the box. To smooth out a painting once it is dry, iron it on the lowest setting between sheets of tissue paper. You can also lay it on a sheet of glass or Formica, with the side of the paper containing the most pigment facing up, and wet it with a brush. (Don't use a sheet of plastic for this because the painting will stick!) Blot-press out any bubbles with a soft paper towel, and then let the painting dry again. Peel it off carefully from one corner after it has dried flat.

A Few Variations

You do not need to take pot luck with the outcome of a solar painting. Many fascinating effects occur accidentally, but others can be planned on purpose.

Ridges that lift up part of the painting surface can be created by placing wrinkled plastic below lightweight paper, by soaking and drying medium-weight paper to make it buckle, or even by folding or crumpling the painting surface itself. For control over placement of color, try using a pipette to add and remove liquid exactly where you want it; this won't disturb the pigment that is already there.

Concentric rings and feathered effects can be achieved by letting puddles of color dry slowly and removing water at regular intervals. If you want to try adding smaller rings within a dry depression, first add water to create a puddle smaller than the existing ring, and then introduce small amounts of pigment to give color to the edges as it dries. Remember that if you add color while the puddle is still wet, the colors will mix.

Once you have mastered the technique of making one solar painting at a time, you can make two or even three paintings simul-taneously by sandwiching objects between the sheets of paper and leaving them to dry in the solar box. For this technique, use stiffer paper for the bottom sheet and more maleable paper (such as tissue paper or rice paper) for the top sheet. The lower side of the top sheet should touch the water, but its upper side should start out dry. As the lightweight paper absorbs moisture, it will mold itself to the contours of the objects below. (You can spray on more water to help it do this.) The two paintings will echo each other but will not be identical. The bottom sheet will retain more color, since the pigmented water dried on top of it rather than below it, and the colors and texturing objects usually leave different impressions on the two images.

Other methods of solar painting involve using objects as resists, and drawing lines of hot wax to isolate different colors in separate areas. You'll soon read more about all these solar painting techniques.

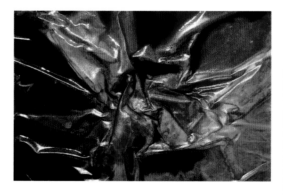

Here I put wrinkled plastic into a solar box and added enough water and ink to fill the low areas; the highest folds of the plastic protruded from the liquid. I then added a sheet of fine paper, which began to absorb the color and mold itself to the plastic. In fact, in the photograph above it is difficult to see the paper at all!

The flattened finished painting reveals where the paper was lifted out of the color by the plastic. The side that faced downward in the box will always retain the most color, but either side can be chosen for the finished painting.

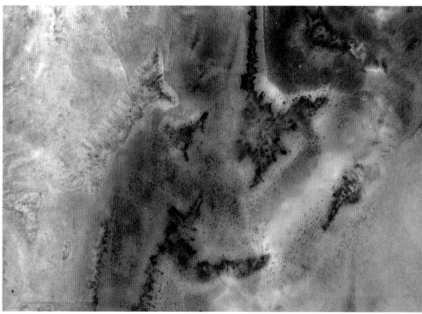

Solar Heat, Maxine Masterfield. *22″ x 30″ (56 cm x 76 cm), inks on Dippity Dye paper. Private collection.*

Exploiting the Layering Process

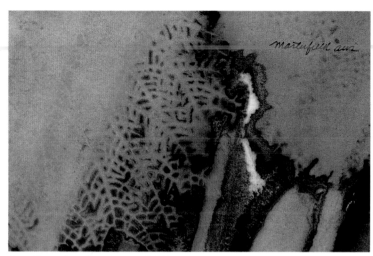

SEA FAN, Maxine Masterfield. *16" x 26" (41 cm x 66 cm), inks on Rives BFK paper. Collection of Gloria Gemmill.*

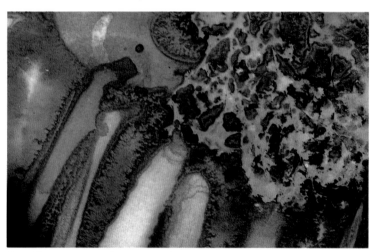

SEA FLOWER, Maxine Masterfield. *18¼" x 30" (46 cm x 76 cm), inks on Japanese rice paper. Collection of Joyce Parmley.*

The two paintings above were created simultaneously. Sea Fan was the bottom sheet on which I placed a sea fan, flat-ribbed side down. I then added color and water. The parts of the paper that were not weighted down with the fan warped and rippled, and the color seeped into the valleys.

I then placed the fine paper for Sea Flower *on top. Since the top side of the sea fan was less regular than the bottom side, its image on the top sheet looks more like flower clusters.*

For Arctic Dreams II, *I again placed a sea fan over the paper, and also some fabric in the upper corners. This time the image registered with remarkable clarity, descending like layers of patterned ice over a dark pool.*

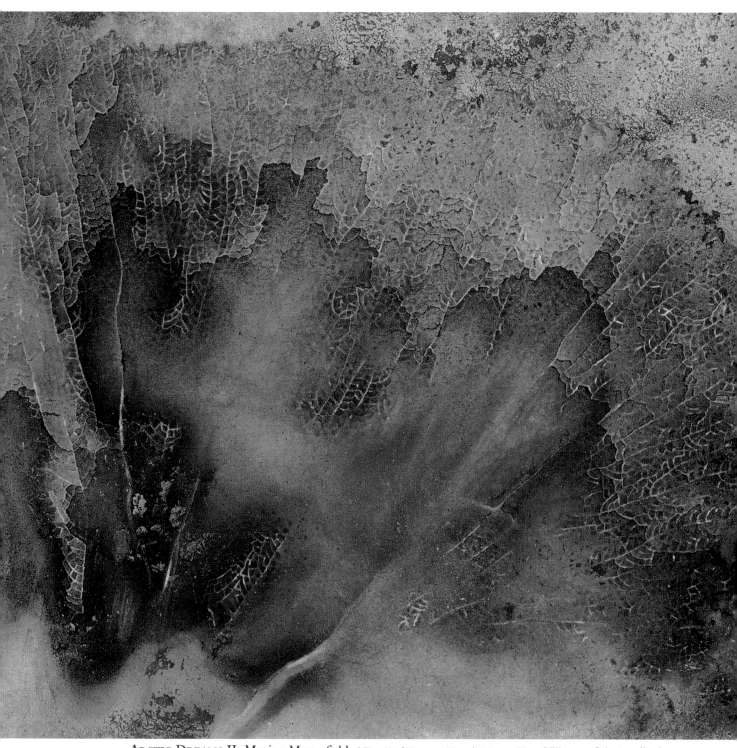

ARCTIC DREAMS II, Maxine Masterfield. *26" x 40" (66 cm x 102 cm), inks on Rives BFK paper. Private collection.*

Creating Ridges and Topographical Effects

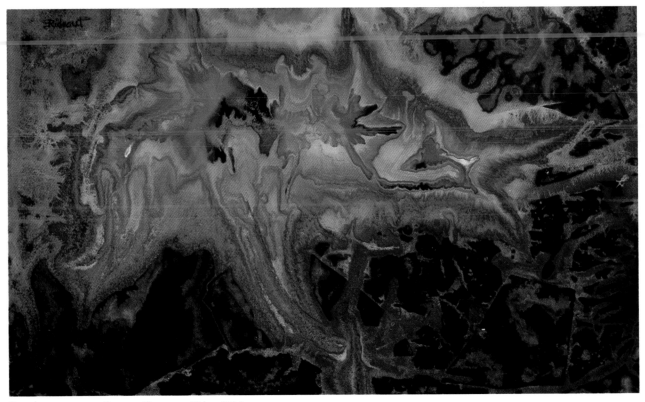

SYMPHONY OF A SOLAR BLOOM, Edna Rideout. *7¾" x 14"*
(20 cm x 36 cm), inks on rice paper. Collection of the artist.

"This painting blossomed over hard plastic shapes, crumpled paper, and some willow leaves and twigs in a cookie sheet. I used a pipette to add color and water under the fine paper. I could watch the paper absorbing color while it was wet. The underside had glazed areas with a special vibrancy, and this became the painting surface."

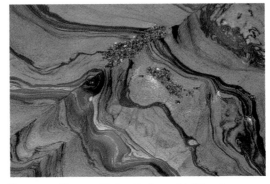

ERODED ROCK, Point Lobos, California. Photograph by Howard F. Stirn.

Solor painting allows you to create angled crevices, slender veins of color, and grainy textures like those shown in this photograph.

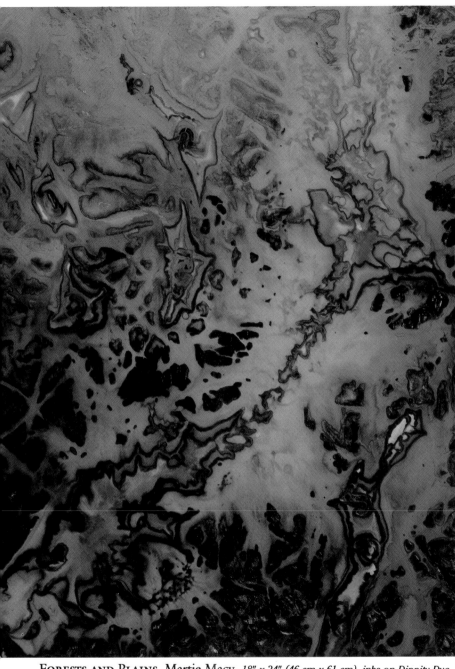

"This is from a series of paintings I did that were inspired by a book about a survey of the world from outer space. Using the solar box lined with plastic, I created hills and valleys by placing pieces of cloth and small objects under the paper. I poured on water, then ink, using lighter colors on the hills and darker colors in the valleys to give the illusion of depth.

"I watched for textures to appear as the painting dried in the sun. In some places I added more color with a pipette while the painting was still wet. Because there was less water by this time, it was perfect for adding the deep contrasting touches in some of the valley regions. The shiny areas were where the painting had been lying on plastic in the bottom of the solar box."

FORESTS AND PLAINS, Martie Macy. *18" x 24" (46 cm x 61 cm), inks on Dippity Dye paper. Collection of the artist.*

Controlling Puddling Effects

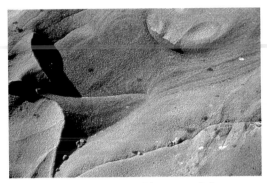

SANDSTONE TEXTURES. Photograph by Howard F. Stirn.

The weathered sandstone in the photo above shows the kind of grainy textures and feathered edges found in nature wherever rainwater has washed sediment into lines of color. With solar painting, you can produce similar effects, using paper as your stone and pigment as your sediment.

The Subtracted Puddle and Ocean Tenants were cropped from the same large solar painting.

I started by soaking medium-weight paper for several hours in a solar box and deliberately letting it buckle as it began to dry, so that its depressions held uneven puddles of water. I then sprayed color into those puddles of water, and later added more color with a pipette. The painting dried in stages. By removing liquid at regular intervals with the pipette, I was able to achieve concentric feathered edges in several places.

After the painting was dry, I flattened it out by weighting it down. The nautilus shell patterns were collaged on last.

THE SUBTRACTED PUDDLE, Maxine Masterfield. *7" x 11" (18 cm x 28 cm), inks on Arches paper. Private collection.*

OCEAN TENANTS, Maxine Masterfield. *30" x 20" (76 cm x 51 cm), inks and collage on Arches paper. Private collection.*

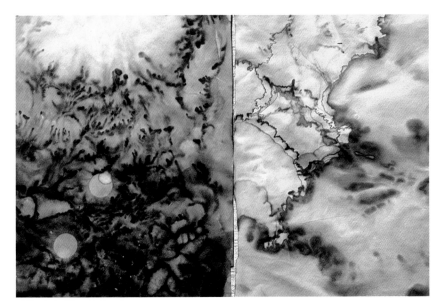

In both these examples, I added water to create light areas. The water diluted the puddles and pushed back their perimeters, causing a feathery branching effect. The resulting texture is a lot like a topographical map or a view of mountains from an airplane.

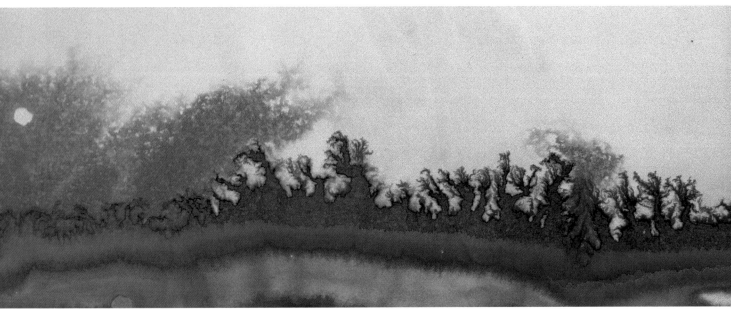

PINES, Maxine Masterfield. *12" x 33" (30 cm x 84 cm), inks on Rives BFK paper. Collection of Kumiko Yamamoto.*

I fastened the paper to a board and then set it into a solar box at an angle. After misting the paper with water, I added permanent blue along the top edge. It slowly bled down the tilted paper, forming the branches of trees very much like the riverbank scenes at Myaka State Park. These feathered effects took hours to spread. When I was satisfied with them, I laid the board flat to dry.

Maintaining Boundaries

The swirling lines here were made with wax, a technique you'll see in more detail a bit later. Puddles of color formed in the depressions of buckled paper. Lighter areas within darker ones were created by removing some of the color with a pipette when part of the liquid had already evaporated.

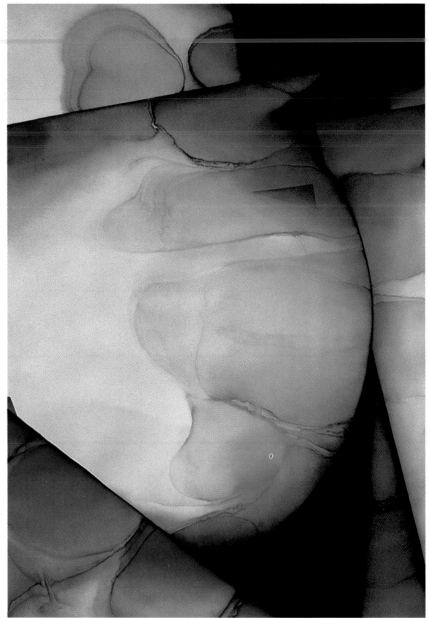

Hada, Elizabeth Sanford. *29" x 41" (74 cm x 104 cm), watercolors on Arches printmaking paper. Collection of Carol and Michael Heideman.*

"I work on an unstretched printmaking paper, which buckles very nicely and helps shape the interaction of the water and paint. As the liquid evaporates, usually overnight, the color concentrates at the edges of forms and in the indentations. On occasion a series of lines may form near the top of a rise, echoing the ripple marks in sand or on the surface of a body of water. Although I carefully controlled the boundaries of each form in Hada, *what happened as the liquid evaporated was often a surprise. Some of the shapes were painted over parts of others, which partially obscures the underlying forms and adds bits of mystery."*

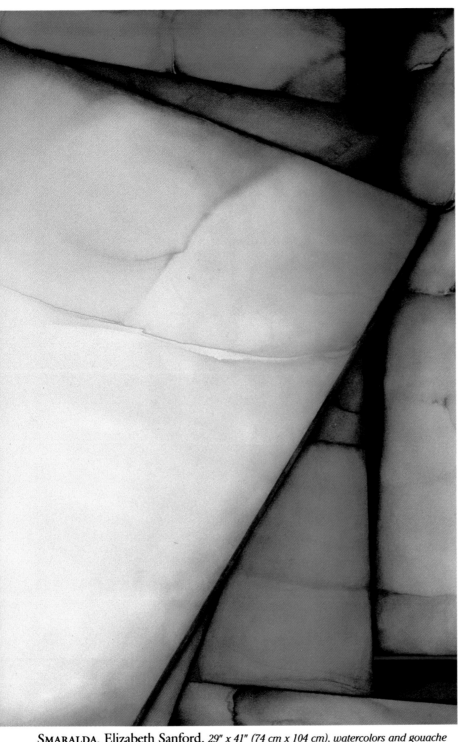

"Smaralda *is part of a series of paintings exploring overlapping planes. Like all my work, it was only partially planned. I enjoy the kind of surprises watercolor brings and consider each piece to be a dialogue between myself and my materials.*

"I made sketches, chose the best design, and drew each shape with clear water that I could easily adjust. I worked on each form separately. When its edges were satisfactorily defined, I added enough water to transform the unstretched paper into a series of rises and depressions, resembling hills and hollows, with swirls of liquid color in the depressions. I dropped concentrated liquid watercolors into some of the valleys and waited until the paper was dry before working the next area. The dark negative areas were painted last to avoid bleeding.

"Transitions between wet and dry sections were sometimes made with a small sponge. I also used dark gouache near the edges of forms to give them more substance and increase the spatial quality."

SMARALDA, Elizabeth Sanford. *29" x 41" (74 cm x 104 cm), watercolors and gouache on Arches printmaking paper. Collection of the artist.*

Using Objects as Resists

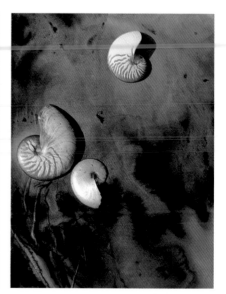

The Nautilus. Photograph by Gail Shumway.

The nautilus shell has been my favorite natural shape for many years. I have dozens of them in my studio, many sliced in half so that I can use the flat side as an image-making tool. Here I placed several of them over the paper in a solar box, and then added about ⅛ inch of water. Whether or not the paper ripples, and no matter how the color washes down into low areas, objects set on top of the paper will prevent much of the color from seeping underneath, and thus leave a recognizable impression.

Once the water evaporated, I removed the nautilus shells and other objects. The sticks and wadded plastic under the paper left vague linear impressions, but the shell images are clearer. In some instances you can see traces of the tiny spiraling chambers inside them. This is because any color that does seep under an object is attracted to that object's contact points with the paper.

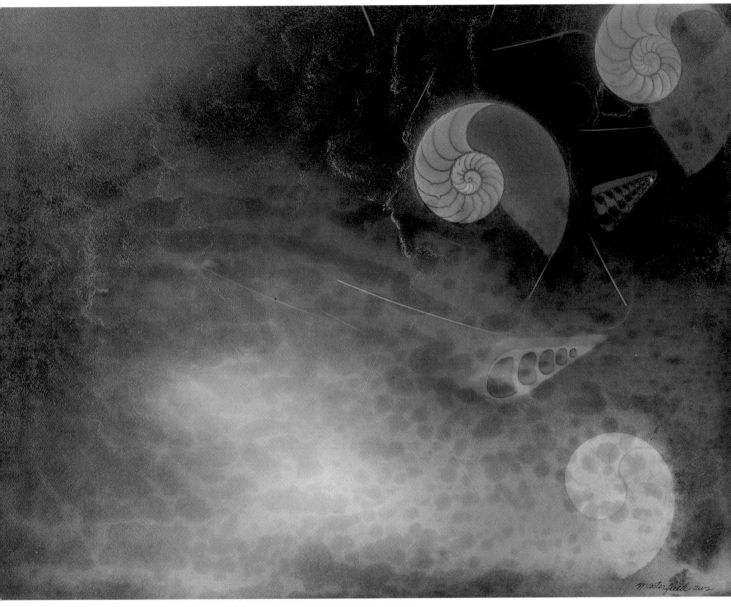

A Tranquil Sea, Maxine Masterfield. *28" x 36" (71 cm x 91 cm), inks on Aquarius II paper. Collection of the artist.*

To me this painting has a transparent, dreamlike quality. The bright filtered light and dappled textures are what I would expect of deep, quiet water, far below the surface tumult of the ocean.

An inch of water floated over this painting before I added the shells and color. The walls of the nautilus shells sealed the blue out during the solar drying.

Using Wax Resists for Linear Effects

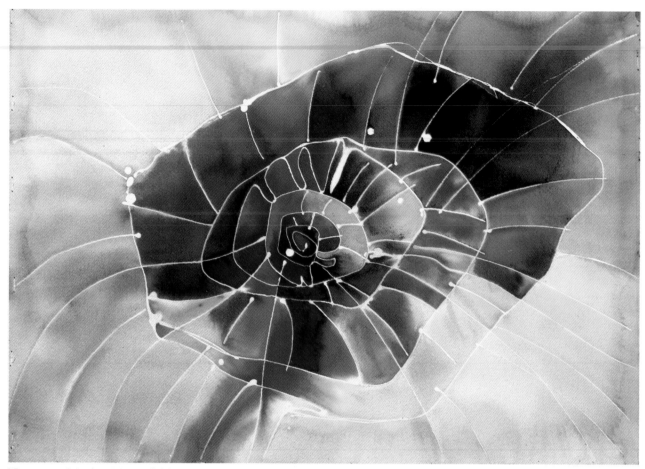

NEBULAE, Maxine Masterfield. *22" x 30" (56 cm x 76 cm), inks on smooth side of Arches cold-pressed paper. Collection of the artist.*

The finished painting contains a pleasing combination of shapes almost solid in color and shapes with many subtle gradations of tone. When I peeled off the dark wax, the original white of the paper was preserved beneath it.

If you don't have a batik tool, you can create a similar effect with ordinary string. Arrange the string in an open design on hot-pressed or cold-pressed paper. Spray on water, and then use a pipette to add colors inside the string-enclosed spaces. Because the string does not form as watertight a barrier as wax lines, carefully place a sheet of tissue paper over the string and colors. It will absorb enough of the colored puddles to prevent them from bleeding through the string.

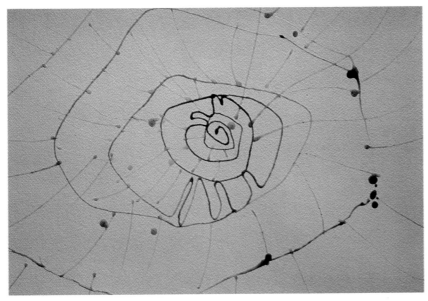

Lines drawn in hot wax onto dry paper can be used as barriers to prevent colors from mixing. For this technique I highly recommend Aquarelle Arches Grain Satine paper, which has a very smooth surface, and a hot wax batik tool with a broad opening, which allows you to control the width and height of the wax line. Several kinds of wax crayons can be melted for use with a batik tool; I like Crayola best.

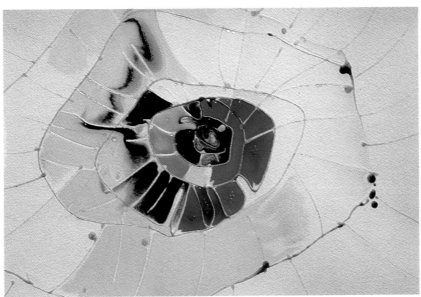

Now put your wax drawing into your solar box, in the location where you will let the painting dry. (If you try to move it after adding colors, they may slosh over the wax lines and mix.) Spray water into the section or sections you wish to work on, and then add color with a pipette, a few drops at a time. This way you have control over the exact hue and don't accidentally stain the paper too deeply right away. You can also use your pipette to mix colors in neighboring sections.

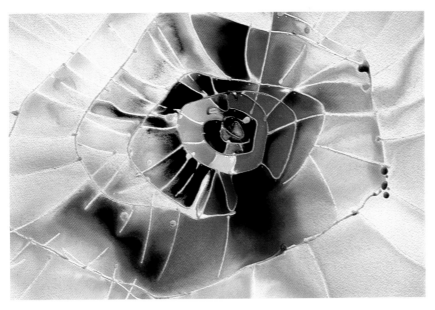

By this stage I had covered the entire surface with color in different ways. Some of the color mingling in the outer layers was accomplished by adding more water to make the color puddles spill over their wax walls. A hake brush is very helpful for pulling color all the way to the edges of the paper. Before you leave your painting to dry in its solar box, weight down its edges with stones so that they won't ruffle in the breeze and spill some puddles of color.

Exploring Rhythmic Patterns Through Line

Water can form many lines of raised ridges, similar to the wax lines from a batik tool. Slowly rippling water fractures reflections and makes them abstract.

LAYERED WATER. Photograph by Howard F. Stirn.

FROM THE PIER. Photograph by Shirley Hummel.

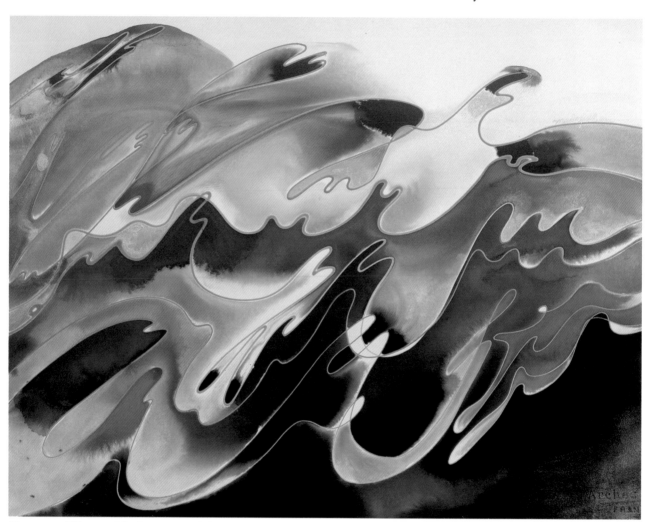

DANCING WATER, Maxine Masterfield. *30¼" x 40" (77 cm x 102 cm), inks on Arches hot-pressed paper. Collection of Mr. and Mrs. George D. Wray.*

I developed both Dancing Water *and* Starborn *with an electric batik drawing tool while listening to the music of Patrick O'Hearn. I began* Dancing Water *by drawing the looping lines with melted silver crayons. Next I poured water over the entire surface and slowly added colors to the rhythmic shapes: light pinks and yellows first, then indigo. The wax line barriers kept the pale separated from the dark, except where they shared the same forms.*

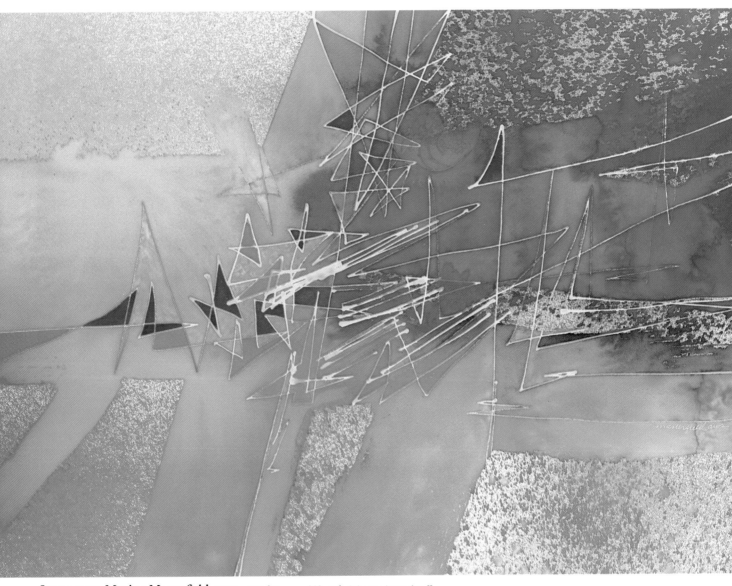

STARBORN, Maxine Masterfield. *29¼" x 40" (74 cm x 102 cm), inks on Aquarius II paper. Courtesy of The Alan Gallery, Berea, Ohio.*

Starborn *was named after the new age rhythm that guided its straight, flying lines that dart from point to starpoint. The wax lines hardened almost as quickly as they were drawn. I then applied wide bands of water with a hake brush, and sprayed red, blue, yellow, and burnt sienna inks. Where the surface was wet, the color softened and spread to meet the wax lines. Where the ink drops fell on the dry surface, they remained drops. Deep colors were added within small triangles to bring out the shapes.*

Capturing Patterns of Frost and Ice

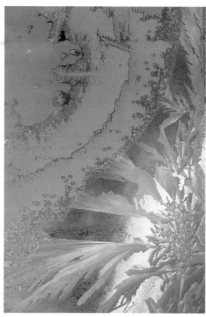

"During the cold winters at my home in Michigan, I am constantly on the lookout for crystal patterns to photograph: lacy, intricate patterns of frost on windows, ice patterns on lakes and streams, and delicate ice-covered foliage."

GLASS PLAIN. Photograph by Kathleen Conover Miller.

ICE FAN. Photograph by Kathleen Conover Miller.

CANYON TEXTURE, Kathleen Conover Miller. *21½" x 30" (55 cm x 76 cm), inks on Arches hot-pressed paper. Collection of the artist.*

"Frosty patterns can be captured on watercolor paper by actually freezing liquid watercolors on the paper in a solar box, and then gently mopping up the excess water and ice as the painting begins to thaw. The drying crystallized pigment is left on the paper in wonderfully delicate patterns.

"Canyon Texture was inspired by the fact that rock formations in canyon walls often resemble the crystal forms seen in frost formations. I chose warmer earth colors to help suggest a geological formation.

"Temperature determines the size of ice crystals. Below 20 degrees Fahrenheit, crystals freeze when they are still quite small. At warmer temperatures, they freeze more slowly and have time to grow, for a more spread-out, feathery appearance. Both textures are evident in this painting.

"If you live in a warm climate, you can make frost paintings in your freezer. Just make sure the surface where you will put the solar box is level. To keep colors from mixing by mistake, you may prefer to add the colors after the paper is in the freezer (depending on its size and design)."

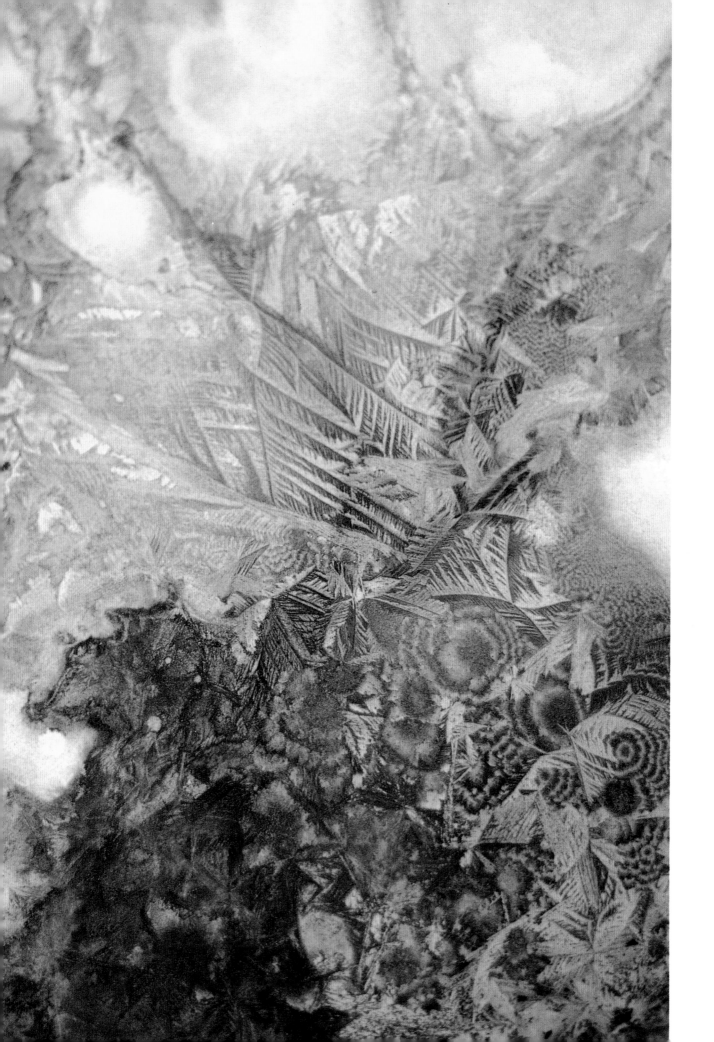

Fracturing
the Picture Plane

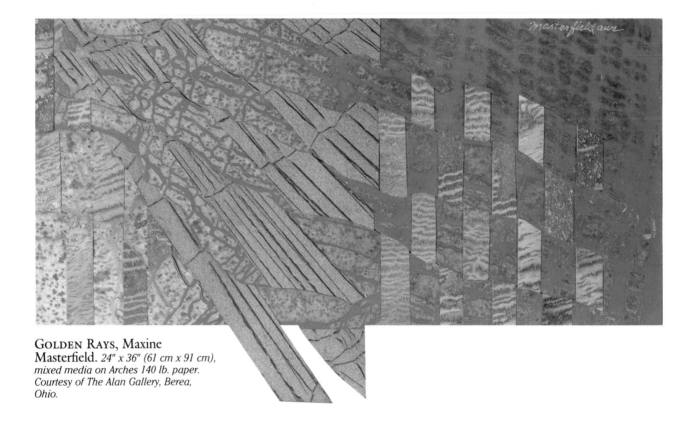

GOLDEN RAYS, Maxine
Masterfield. *24" x 36" (61 cm x 91 cm),
mixed media on Arches 140 lb. paper.
Courtesy of The Alan Gallery, Berea,
Ohio.*

Golden Rays *was woven from three different paintings. First I cut a blue
and green fabric painting in a diagonal wavelike pattern and interwove it
with vertical strips from a lavender fabric painting. I then added several
bands of metallic gold from another fiber painting, letting them project
past the picture's border. The finished product seems to me symbolic of
the sun's power.*

Nature is full of layers. Multiple levels of sediment and rock build up and are then folded and realigned by enormous pressure, creating interesting linear patterns that can be seen when these strata are exposed by erosion or upheaval. Broad expanses of clouds, mountains, or trees appear to us as layers stretching into the distance. Every horizon line we perceive is a kind of layer.

Artists have long dealt with horizon lines that skin smoothly across the picture plane, caress the retreating layers of rolling hills, or swoop and dive up and down jagged canyons. We think about horizon lines when we plan compositions. But the artist who works in harmony with nature knows the secret of the horizon: that it moves with us. It is in our minds.

Perspective, which includes the concept of horizon lines, is not a mathematical system of angles and degrees. It is a mental and visual reckoning of the relationship between where we are and what we see. There are always two ways to change one's perspective on a given scene: to wait for things to move (such as waiting for the sun to lengthen the shadows or the tide to come in), or to move ourselves so that we view the same thing from a different vantage point.

But now let me introduce a third option: to make the move in your mind. Many artists have learned how to *imagine* the perspective that best suits their needs. They realign the tiers of nature, stacking the deck in their own favor, and then they make an image from that inner perspective. This section is about several methods of doing this—fracturing the picture plane to rearrange layers exactly as you want them.

You can layer the surfaces of your paintings with built-up levels of paint, integrating new elements with the old in order to construct a visual effect. You can also use collage, which is one of my favorite ways to combine disparate color schemes and textures in a single composition. Collage is often the perfect way to salvage marvelous scraps of texture from otherwise unsuccessful paintings.

Another way to create multiple layers is to weave two paintings together. This technique allows you to give new life to paintings that have appealing textures and colors but no real impact as images. Combining two such works can create new patterns of arresting complexity—much as time, erosion, and pressure can change ordinary mud into fascinating cliffs of rock.

ATLAS MOUNTAIN VIEW. Photograph by M. E. Hudak.

The earth is tiers of matter layered one over the other in undulating horizontal plains. Even beneath the surface, many more defined strata of rock and sediment lead down to the earth's core.

Collaging Nature's Geometric Rhythms

BETWEEN HIGH RANGES, Maxine Masterfield. *35¼" x 40" (90 cm x 102 cm), mixed media on watercolor papers. Collection of Barbara Ree.*

Between high ranges of the southern Rockies are a series of ridges of steep red sandstone that rise straight up from the highway. One can see lavender strata through them, with light sandy areas at the crests. The sun glows from behind these ridges, making them glitter like gold. This is the vision I had in mind as I completed this painting.

I began by setting triangle shapes of light Japanese paper over a blue fiber painting. I then sprayed gold metallic paint over and through these triangles, masking and preserving the blue beneath them, while letting some texture of gold show because of their open pattern. After removing the triangles, I collaged parts of another fabric painting (done in sepias) to the foreground. To complete the composition effect, gold lines were added to accent the pointed, clifflike structures.

TRIANGLES IN MOTION, Elaine Albers Cohen. *30" x 40" (76 cm x 102 cm), mixed media on Morilla paper. Collection of the artist.*

"The inspiration for this collage came from reading bits of my husband's scientific books, especially Gleick's "Nature is full of systems that almost repeat themselves but never quite succeed." My goal was to do a patterned geometric painting that gave the feeling of repetition and movement.

"To achieve this I cut a series of two basic shapes that would be repeated forward, backward, and upside down. I used a variety of papers for my geometric shapes, including some of my discarded monoprints of deep reds and blues. I painted over these colorful papers with thick acrylic paint, and then scratched into the wet paint with a dull knife to draw lines and textures. The color underneath was revealed as the top paint was scraped away. I worked on positive and negative spaces as I composed, building a visual rhythm."

Interpreting Strata

ARIZONA CANYON. Photograph by Joan Ritsch.

NEW AND OLD. Photograph by Howard F. Stirn. *Eroded rock and pebbles, Point Lobos, California.*

"Ancient Rumors #11, *because of its format, involved a little more planning than usual. Once I made the decisions about what the big areas would be like, many other details of the painting were more spontaneous.*

"First I applied overall acrylic washes and then established edges and divisions. I sketched in the bottom parts of the painting and painted in vertical strips of paper shapes to imply layers of torn scripture remains from earlier times. The top was developed into wall structure. In some places I interspersed bits of metallic and opaque paints with transparent paint and pastel pencil detail."

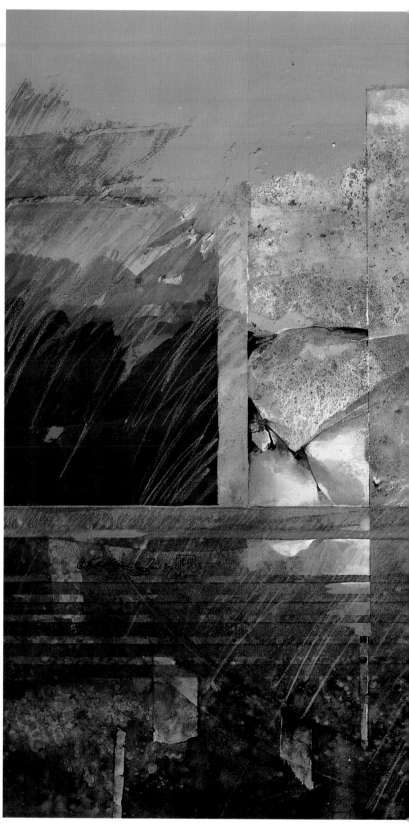

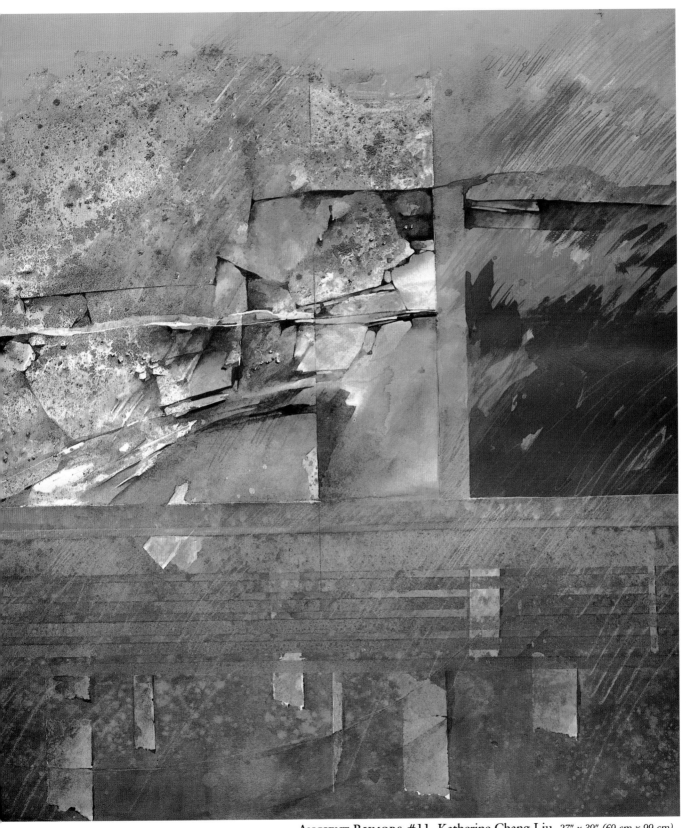

ANCIENT RUMORS #11, Katherine Chang Liu. *27" x 39" (69 cm x 99 cm), mixed media on 300 lb. Arches cold-pressed paper. Collection of the artist.*

Creating the Illusion of Multiple Facets

*"All my work is based on nature—
the land. There is a drama in the
land, constant movement and
change, both in color and contrast.
To paint, on the other hand, is to
make a statement of logic, to lock
something into a piece of paper
with color, line, and shape. To
come a little closer to conveying
the drama and changeability of
nature, I enjoy taking real shapes
(the actual) and breaking them to
form a fractured, mobile view of
the outdoors that transcends the
actual while still representing it.*

*"Freeze Time was begun in a
very loose, organic, transparent
manner. As the painting progressed,
I taped off areas with masking tape
and then applied opaque paint.
When this was dry, I taped new
areas and repeated the process
until I felt that the design was
sufficiently complex. Thin lines,
stencils, and rectangles of color
were added to complete the
composition and effect."*

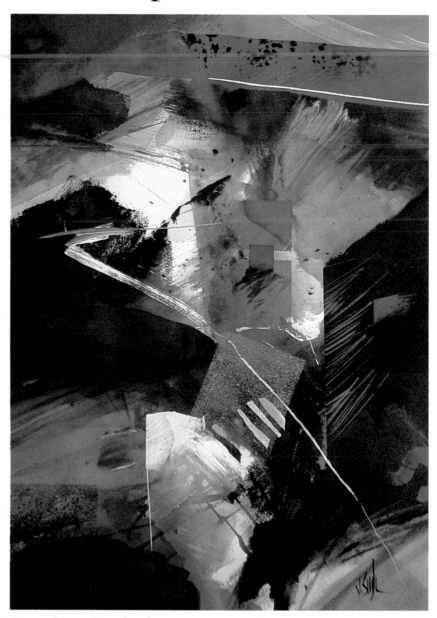

FREEZE TIME, Jerry Seagle. *30" x 23" (76 cm x 58 cm), acrylic on Arches 140 lb. cold-
pressed paper. Collection of the artist.*

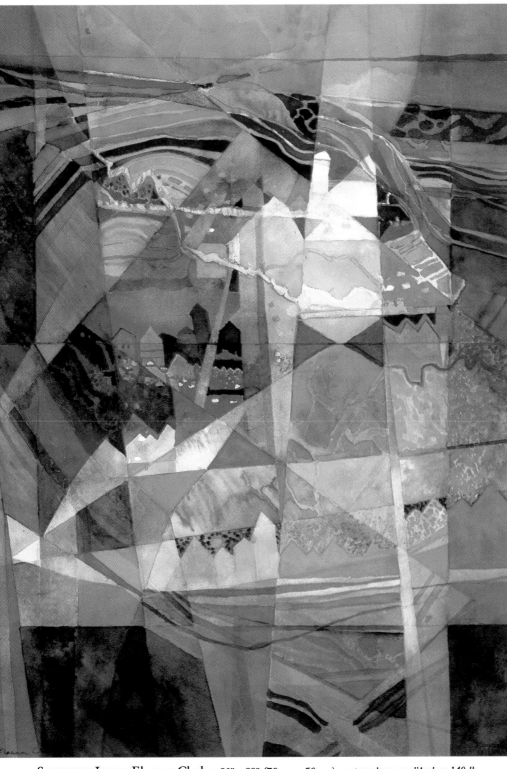

"As I started this painting, a memory surfaced in my mind: an island named Iona off the coast of Scotland that had enchanted me several years earlier.

"After painting the initial, loosely placed washes, I gradually broke up the surface in defined areas, like a patchwork quilt. I created some architectural areas surrounded by patches of stripes, dots, marble texture, and ripples that represent fields, sheep, stone, and water, respectively. The transparent and opaque areas act as foils to one another."

SCOTTISH ISLES, Eleanor Clarke. *30" x 22" (76 cm x 56 cm), watercolors on d'Arches 140 lb. paper. Collection of Mr. and Mrs. Paul Tavilla.*

Weaving Paintings Together

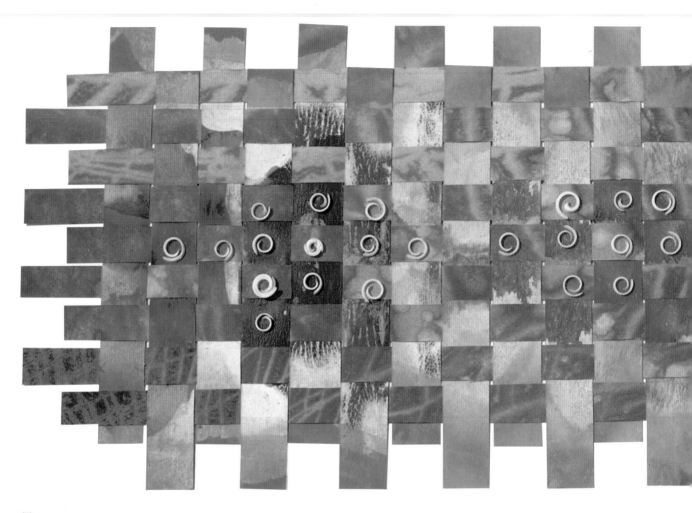

Touch of Dawn, Maxine Masterfield. *10" x 23" (25 cm x 58 cm), inks on Aquarius II paper. Collection of Dawn Gable.*

Quite often you can create a successful work by weaving together two discarded paintings with appealing textures but weak images. In this example I chose to stagger all the edges evenly. I also glued thin slices of seashells in a pattern.

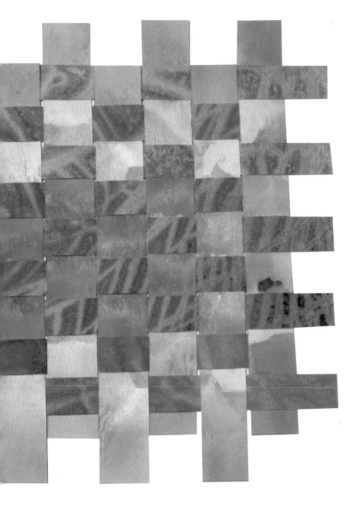

Start with two paintings whose colors and textures harmonize well. They must be the same shape and size, and should preferably be on similar-weight paper. Rule lines on the backs, number the strips to keep them in the order of the original pattern, and cut them apart. Strips can change direction and have different widths. They can be cut straight in one painting and diagonal or wavy in the second. Especially if the paper is lightweight, keep the strips wide enough not to tear.

Now place the cut strips in order, face up. I find a grid cutting board (the kind available at fabric stores for dressmaking) to be very helpful for keeping the outer edges straight. Keep the weaving tight and exact. You can alternate over and under, or weave some other pattern of your own invention. Once you have finished weaving, dab Velverette glue under the outside edge of each strip so that it won't slip out. Iron-on interfacing from a fabric store is a good backing for lightweight woven paintings; you can also mount the woven painting to a mat board.

Incorporating Woven Elements in a Painting

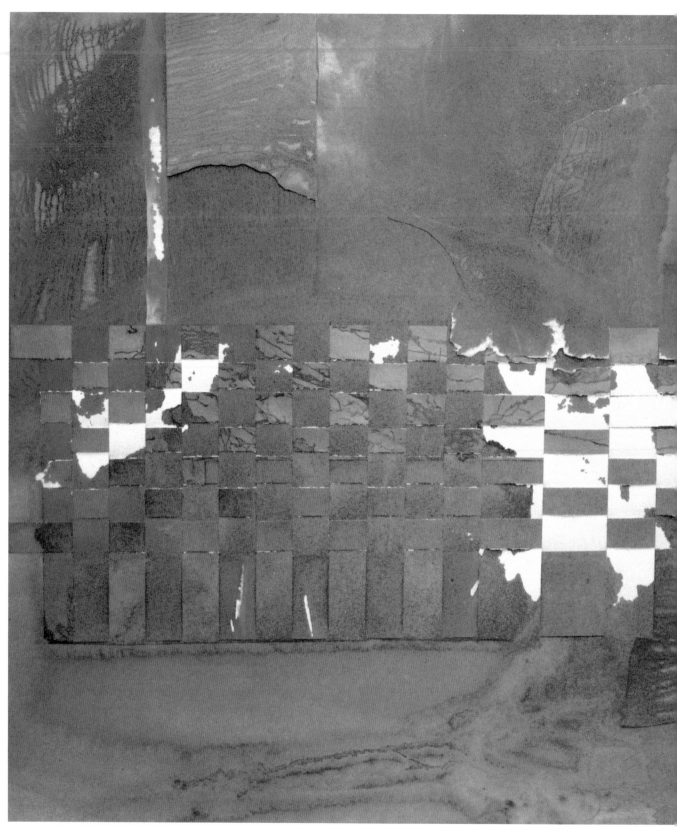

WOVEN WINDOW, Karlyn Holman. *22" x 30" (56 cm x 76 cm), mixed media on Strathmore Aquarius II paper. Collection of the artist.*

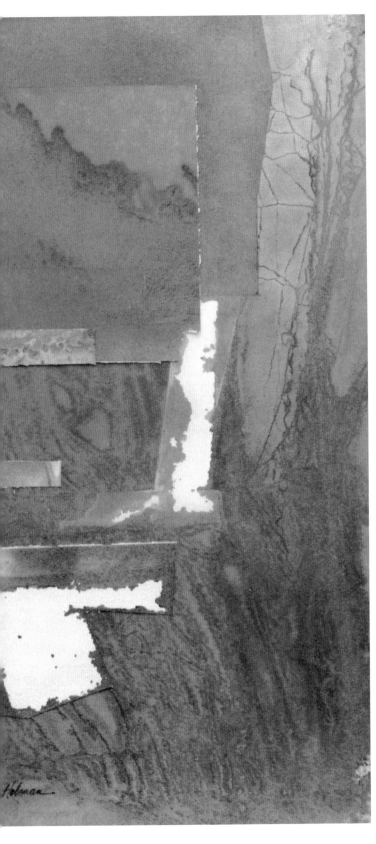

"*For* Woven Window *I collaged and wove together two ink paintings textured with waxed paper and fabric. I also sprayed gold enamel in different areas to preserve the forms and fabric lines.*

"*When the paintings were dry, I planned which parts of the paintings I wanted woven, and which would remain intact. I cut and wove the sections together, gluing the ends down. The result is an unusual combination of textures and layers.*"

Working with an Existing Design Element

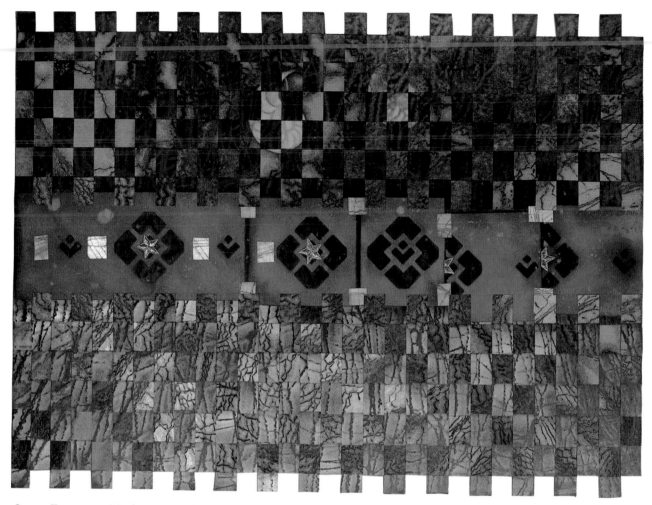

STARS FOREVER, Maxine Masterfield. *32" x 42" (81 cm x 107 cm), mixed media on Aquarius II paper. Private collection.*

You can save a distinct image on one of the paintings and only weave around it. The portion you surround with the weaving can be any size or shape, but the sections you are weaving together must match.

One of the two paintings in Stars Forever *had a horizontal column of blue across it. I decided to preserve it and build the weave around it. To do this, I cut vertical slits above and below the column, cut the second painting in horizontal strips, and wove them together.*

You can still see the shell impression in the second painting, between the darker squares of the first. For more important accent of the wide blue column, I added a cloth star over the center of each pattern.

Adding a Dominant Design Element

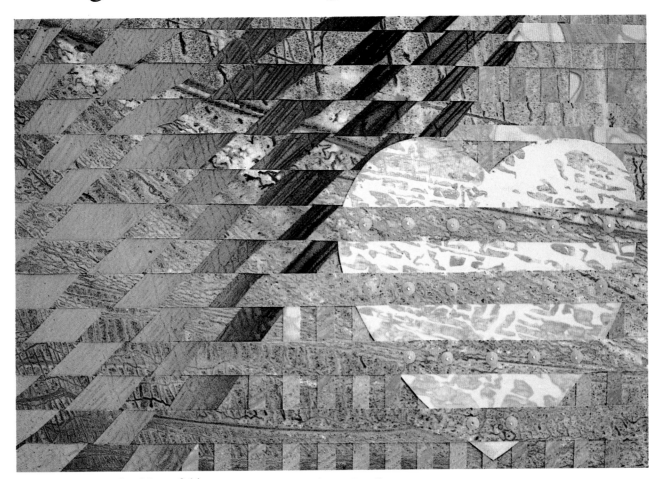

SWEETHEART, Maxine Masterfield. *22" x 34" (56 cm x 86 cm), mixed media on Arches 140 lb. paper. Collection of Joy Dibble.*

Each of the three paintings that make up Sweetheart *was cut into bands of differing widths. The horizontal strips were half an inch, the vertical strips were one inch, and the diagonal bands were tapered. After the three were woven together, but before they were glued down, I added a heart shape cut from a discarded monoprint.*

The heart shape was slipped in under the horizontal lines, and even though there was a change in the hue and value between the strips, I wanted the heart to attract more serious attention. I decided to embellish just the strips that crossed over the heart with pink sequins. That helped offset the attention drawn by the dark tones to the upper left.

To weave two entire paintings together diagonally, cut them into diagonal strips in the planning stages. The second painting must be ruled and cut running in the opposite *diagonal direction from the first. Two of the corners will contain some small pieces, so be careful about securing them during the weaving process and when finishing up.*

Embellishing Woven Paintings for Focus

RHYTHMS IN BLUES, Maxine Masterfield. *24" x 32" (61 cm x 81 cm), mixed media on Arches 140 lb. paper. Private collection.*

For this painting I wove together a yellow and ochre fiber painting and a string-pattern painting in blue, orange, and yellow. Even if the two paintings contrast well, a tabby weave (simple over-one-and-under-one) always needs some focused center of interest, such as added color for punch, embellishments that make it sparkle, or added lines.

In the case of Rhythms in Blues, *I put on some music and let it inspire me to draw lines that wiggled and snaked around the weave to the music. I even added some gold metallic dots to represent the music notes. The accents of the string painting triggered the quality of the added lines.*

Another good way to enliven a woven painting is to pull out one or more strips, recolor them with a contrasting shade, and reinsert them. To make them more visible in the design, you can reweave them unevenly (slip them under every third or fourth strip, for example).

THE SNOWFLAKE, Maxine Masterfield. *29" x 36" (74 cm x 91 cm), mixed media on Aquarius II paper. Private collection.*

Some very effective woven works are composed of two or more paintings that are similar in color and value. Others, like this one, combine two paintings very different from each other. In either case, what's needed is a clear focus. Woven paintings are decorative because they are fractured into an overall pattern, almost like a patchwork quilt. But they still need a sense of direction just like all other paintings.

The woven combination of paintings for The Snowflake *had a lot of brilliance but needed a more definite focal point. I had some magenta paper left over from the edge, so I tried gluing rectangles of it down the center. I then fastened the metal snowflake in the largest of these rectangles, and glued copper sequins in a row beneath, creating a dotted column. I also added some swirling lines with gold paint to trace the possible movement of the snowflake in the wind.*

Reflection, Repetition, Symmetry

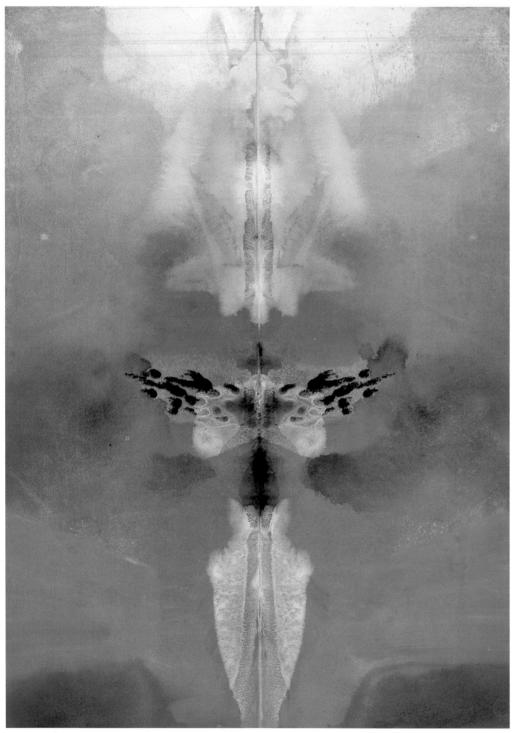

HOVERING SPIRITS, Maxine Masterfield. *40" x 32" (102 cm x 81 cm), watercolors on Aquarius II paper. Private collection.*

One of my favorite ways of looking for new designs is to hold a straight-edged mirror perpendicular to the surface of a painting and slide it along, finding fascinating reflected images. Each time I reposition it and see the new reflection connect to its real half, I get involved with the magic of it. Any form or part of a form suddenly becomes double in perfect symmetry—often with startling results.

Nature is teeming with symmetrical forms. Virtually all creatures, even one-celled animals, contain two mirrored halves. Most plants have some form of radial symmetry. And where there isn't actual symmetry in nature, there is asymmetrical balance.

Some artists shun obvious symmetry in their work, preferring to strive for a different kind of balance by using interest, complexity, and drama rather than central focus. But there are times when experimental artists find symmetry useful for its symbolic possibilities. Besides, symmetrical paintings are faithful to nature. It was the symmetrical loveliness of landscapes reflected in water that inspired me to experiment with different ways of creating mirror images—of lifting, duplicating, and reversing other images.

This section contains symmetrical paintings made by folding paper and rolling color between the two halves, much the way images are made for Rorschach tests. Since my first look at the cards used for these tests, I've been intrigued by their endless possibilities of design creation. The tests work because the symmetrical images are ambiguous and open to individual interpretation. This is an advantage for the artist as well as the psychologist: Everyone who looks at your painting will have a unique personal reaction to it.

This technique is a wonderful way to warm up before doing more complicated paintings, much the way dancers begin with stretching exercises. Rolling paint between folded halves of a sheet of paper can limber up your painting arm and your visual imagination, enabling you to gather momentum for other more demanding painting projects.

For Hovering Spirits, *I misted the colors with water to make them mingle, and rolled not just outward from the crease but also parallel with it. This process spread pale colors over the entire paper surface. The last step was to add white in three places along the crease and blue-black in the center. Some of it spattered out in tiny amounts and formed the dark, broken pattern.*

PINE, AGAIN. Photograph by Howard F. Stirn.

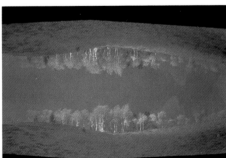

REFLECTING SKY. Photograph by Howard F. Stirn.

Water surfaces were the first mirrors for man and are still the only natural mirror. In Pine, Again, *the lake that mirrors the pine-covered shore extends the image by doubling it with a reflection. In* Reflecting Sky, *a double exposure allows the sky to do the reflecting instead.*

Basic Techniques

Materials

Light to medium-weight watercolor paper, such as Aquarius II 90 lb. or Whatman 90 lb.

Watercolor paints straight from the tube or slightly diluted

Watercolor inks

White ink for lightening colors

Acrylics (optional)

Brayer (a rubber roller used to spread printing ink)

Pipette or eyedropper for adding small amounts of water

Fine mist sprayer for creating wash effects with water

Applying the First Colors

For this technique you don't need expensive paper; in fact, this is a great way to use up paper you don't want for anything else. Just make sure it's not too heavy or too light. Heavy paper won't fold cleanly, and light papers (like tissue or rice paper) are porous enough to let paint bleed through.

Fold the paper in half lengthwise, smooth side in, establishing a good crease. Then open it and place dabs of color in the crease, with space between them so that the hues will have a chance to register before merging. Use enough color to be spread out, but not so much that the colors will all mix together or be pushed out the edges. It is much better to add more color where and when it is needed, a little at a time.

Spreading the Color into Patterns

Close the paper in half again with the dabs of color in the crease. On a flat, smooth surface, use the brayer to roll from the crease outward. Because you are pushing the color as you press on the brayer, you can control the direction you are moving the color, and you can roll it in sweeps and curves rather than just straight out. The more color you have placed in the crease, the farther you can spread it. If you want the colors to meet, roll lightly along the crease.

Refining the Image

Open the paper and review what is happening, so that you can go on composing. New color

can be added anywhere on either side, except close to the outside edges. If you want to thin some of the color, add a few drops of water with a pipette. Water added with a fine mist sprayer will create a wash effect, which you can roll all the way to the edges of the paper.

Close the paper and roll the brayer over it again to spread the new color and water. You can repeat this process as many times as you like. Remember that the last colors you add will be on top.

When you are pleased with the painting, dry it opened flat.

A Few Variations

When you turn the painting so that the crease is horizontal, you may find that it looks like a landscape reflected in water. To capitalize on this, you can add subtle cloud formations and rippled water. First let the painting dry, and then add white paint near the edges and spray it with water before closing the painting and rolling it. This time, keep the rolling motion parallel to the center crease so that the cloud shapes will look properly horizontal and windswept. Once the clouds have dried, make a wash that ripples the bottom half the way a reflection in a lake is usually rippled by a breeze.

Another way to work with reflections is to dampen one of the halves of the paper before you add color and roll it away from the fold. The wet side will feather from the water added, causing the kind of distorted image typical of a reflection in water.

Occasionally the colors in a folded painting may come out too vivid or too dark. This can easily be remedied by adding white ink in the crease and letting it cover the colors. Because the ink is thin, it will not be opaque, and will lighten the colors rather than obliterating them. This process can be used to lighten most of a painting or just a few areas.

You can also layer colors by letting each step dry (with the paper open) before adding more color. If you are using inks that dry permanent, each new layers of colors will not mix with the previous ones. You can intermingle layers of watercolors, inks, and even acrylics if you like the varied effects, but it is best to let each layer dry before you add the next one.

Fold the paper in half and dab colors into the crease.

Fold the paper back in half and use a brayer to roll the colors outward from the center.

Open the paper to see the design, and add more colors where needed. Water added with a pipette will help the colors spread.

I added white in three areas of the crease, a little blue near the bottom, and then a fine mist spray over the entire surface. This let the colors spread to the edges.

One of my favorite themes for symmetrical paintings is increments of shapes that suggest a metamorphosis. This painting method lends itself to pure imagination for interpreting the step-by-step outcomes as they are unfolded.

ALTERED STATES, Maxine Masterfield. *40" x 26" (102 cm x 66 cm), watercolors on Aquarius II paper. Private collection.*

Finding Inspiration in Mirror Images

"To disperse the color in my mirror-image paintings, I use a brayer in a light, curved motion and find that this manner is consistent with the way that I wield a brush. It is fascinating to me that this consistency helps to determine my style, and I thoroughly enjoy letting it all happen.

"The mirror-image technique of painting is good for forcing one to think ahead, because the placement, size, and color of the drops of paint—and the manner in which the brayer is rolled—are two very important elements that influence the finished work."

TULIP, Gracie Hegeman. *9¾" x 14" (25 cm x 36 cm), Deka fabric paint on Nelson bristol plate. Collection of the artist.*

"January on Florida's west coast is a perfect time to work outdoors, and on this day I was painting with new friends who shared my enthusiasm for taking chances with various materials.

"My Soul Has Wings was painted on watercolor paper, creased lengthwise. I used a pipette to drop ink onto the paper—first along the crease, then further away from it for later rollings with the brayer. I opened and closed the paper many times, building up multiple layers of color for a complex design. Where I felt that the colors were getting too dense, I veiled them by adding white ink. You can see through the white ink to the design below, still visible but more subtle."

MY SOUL HAS WINGS, Gracie Hegeman. *30" x 22" (76 cm x 56 cm), inks on Aquarius II paper. Collection of the artist.*

Adding a Background

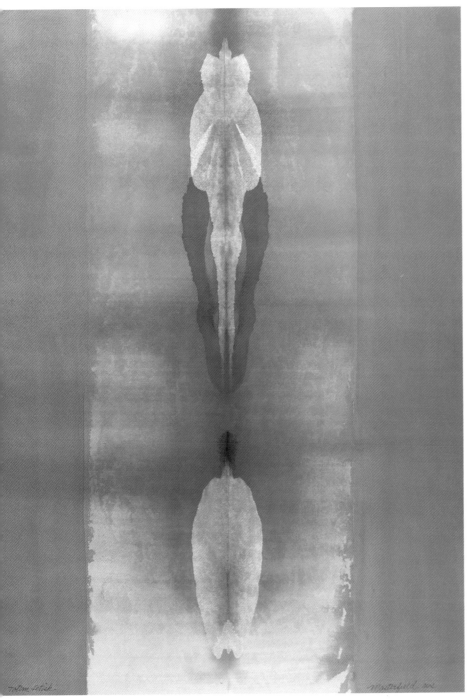

Totem Fetish *reminds me of Georgia O'Keeffe's use of symmetrical bleached bones. I applied three layers of color to the fold, and brushed the pink bands over the edges while the paper was damp. The last layer of color added was the white ink in the center crease.*

TOTEM FETISH, Maxine Masterfield. *40" x 28¾" (102 cm x 73 cm), water media on Aquarius II paper. Collection of Dr. and Mrs. Howard J. Maxwell.*

Suggesting Animal Imagery

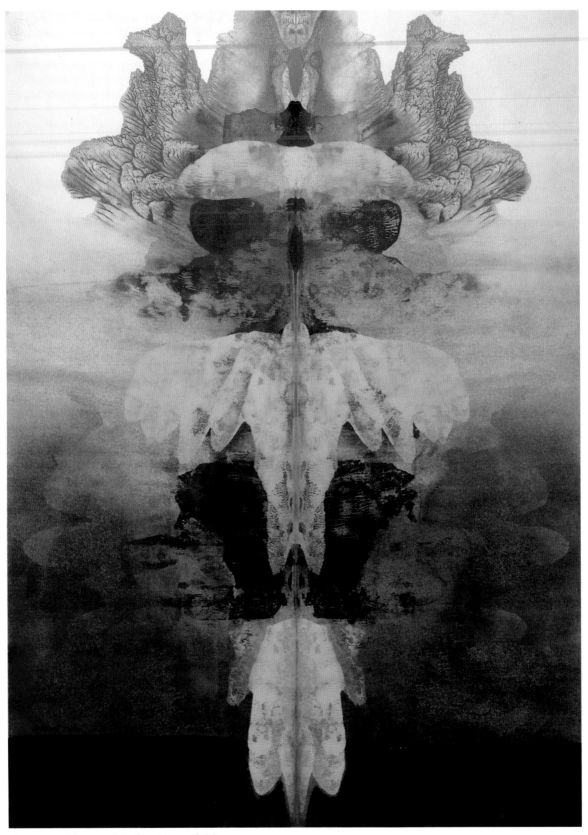

ANCIENT TOTEM, Maxine Masterfield. *40" x 28¾" (102 cm x 73 cm), water media on Aquarius II paper. Collection of Mr. and Mrs. Frank Lockwood.*

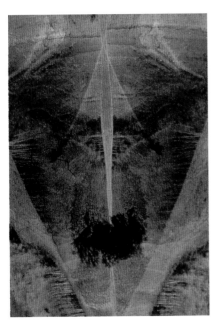

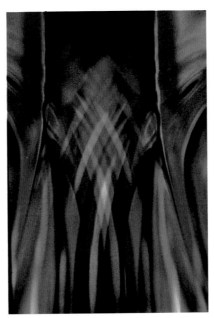

Here are two examples of photographic images combined to overlap and reflect to form a complex new pattern. Aspen Wolf Mask *was made from exposures of an aspen-covered hillside, turned vertically.* Elephant Head Swirls *began with a slide of swirls of water around a boat, superimposed through colored filters.*

ASPEN WOLF MASK. Photograph by Howard F. Stirn.

ELEPHANT HEAD SWIRLS. Photograph by Howard F. Stirn.

I saw in Ancient Totem *a mythical being with supernatural attributes who assumes animal forms. Using a limited palette of red, brown, and blue watercolors in the mirror-image technique, I added black after the first roll of light colors. Each time I rolled and opened the paper, the image changed considerably. To weight the painting, I added a band of black watercolor across the bottom. After this dried, I refolded the paper and added white to three areas. I formed the gray background areas by brushing layers of light watercolor in broad strokes.*

Defining Found Images Within Intricate Symmetry

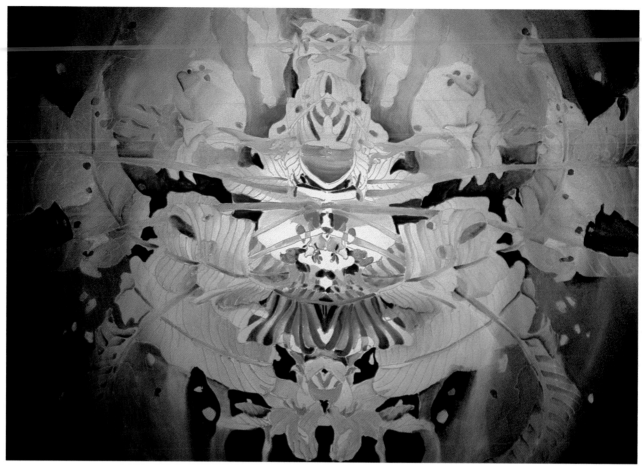

SPIDER LILY, Patsy Pennington. *38½" x 56" (98 cm x 142 cm), water media on Arches paper. Collection of Mr. and Mrs. Charles Harris.*

"This painting started from a line drawing of calla lilies. I held a mirror against all four edges and chose the double image that was most abstract. Then I used tracing paper to transfer the drawing twice with acrylic lines, mirroring into one symmetrical image. Once the acrylic lines had dried, I painted pre-mixed gouache over it, working outward from the center of the composition and getting darker toward the edges.

"Before these washes were dry, I added the bright colors, softening some edges by pulling the paint over the hard lines of the underdrawing. I wanted many lost edges to balance the hard distinct lines."

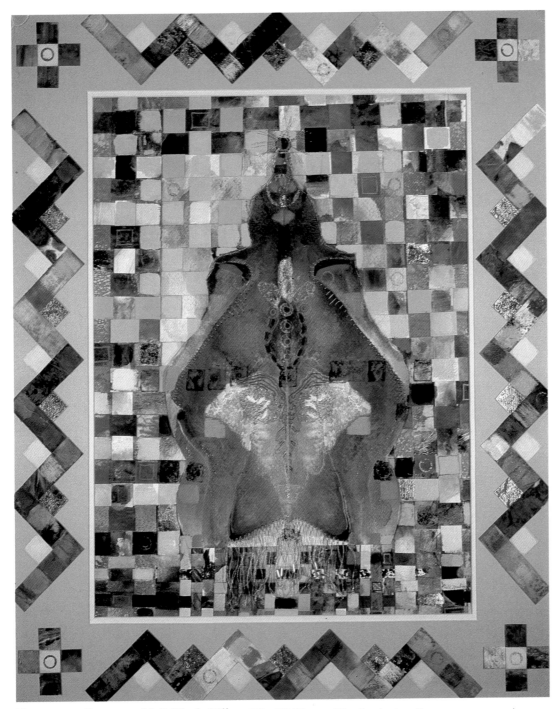

EMPIRICAL GODDESS, Nell Hively Milne. *32" x 26" (81 cm x 66 cm), mixed media on watercolor paper. Collection of Thomas C. Milne.*

"The central form in this painting (whose title is a play on words) was made with the mirror-image technique. I wove the background for it from several other paintings cut into strips. Because the subject called for a fanatical quality, I also used gold thread and gold beads for additional texture. I then reworked the piece with acrylic paint and gold leaf in a quick, freehand style. The quiltlike border mat helps tie the whole piece together."

Creating Multiple Images

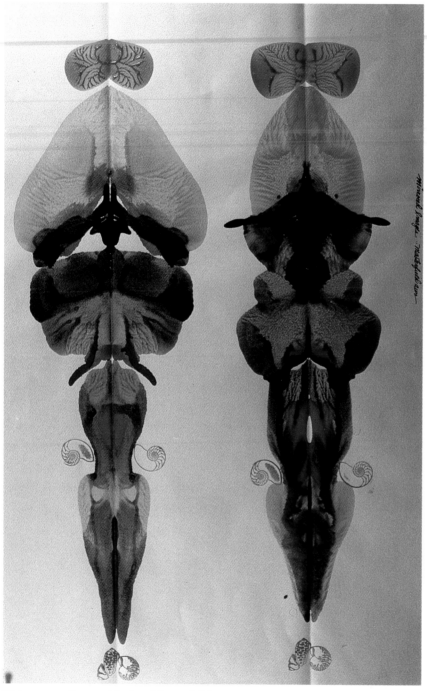

To create a pair of symmetrical designs side by side, fold both long edges of your paper inward to meet at the center, so that you end up with two vertical creases (one-quarter and three-quarters of the way across the paper, but not in the center). Then add and roll colors as usual.

Námo and Irmo *portrays a pair of related but different kindred spirits. I placed the same colors in approximately the same quantities and locations in both creases, folded each side in, and rolled the colors away from one crease a time. Of course the pressure and direction varied enough so that the two images were not identical. I did many additions of new colors the same way. After the images were dry, I added some stampings and lines in black.*

NÁMO AND IRMO, Maxine Masterfield. *40" x 28" (102 cm x 71 cm), watercolors on Aquarius II paper. Collection of Mr. and Mrs. Wendell Galbraith.*

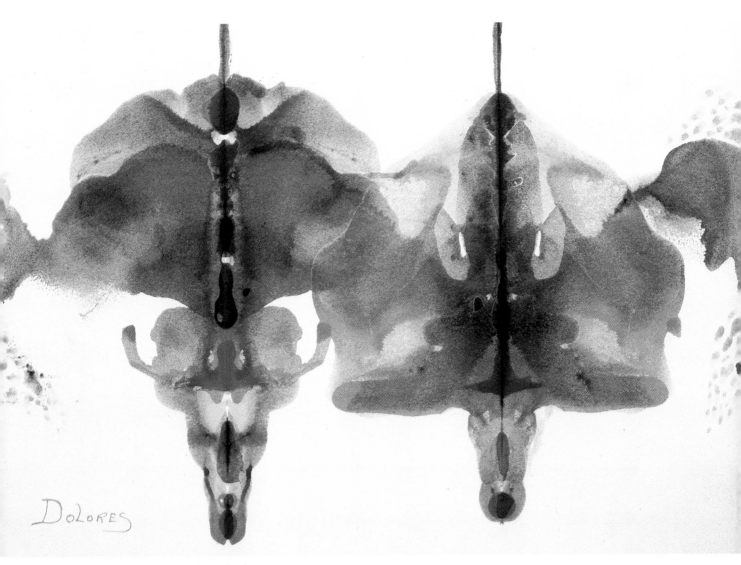

ANIMALS IN DISGUISE, Dolores Roberts. *15" x 22" (38 cm x 56 cm), water media on Arches 140 lb. cold-pressed paper. Collection of the artist.*

"For Animals in Disguise, *I folded the paper in thirds and placed the colors in both the creases, trying to match the places and amounts. I closed and rolled each side separately, not really trying to duplicate the action or pressure. I wanted to see how different they could become, starting with the same ingredients of color. Because the folds were fairly close together and the colors rather wet, the two forms fused together in the center of the painting."*

Developing Figures in Multiple Images

FOUR AMIGOS, Joyce Bennink. *42" x 56" (107 cm x 142 cm), water media on Arches 140 lb. hot-pressed paper. Collection of the artist.*

"The idea for Four Amigos *began with a drawing of two Mexican dolls. In seeking to enlarge the drawing, I placed the edge of it against a mirror in such a manner as to see a double image—and the symmetrical doubling of the drawing seemed more interesting than the two figures alone. Playing around with drawings held to a mirror often triggers new avenues, enhancing interest and possibilities. I can push the subject farther, even into the abstract.*

"The fine gold lines defining the shapes were done in acrylic from a squeeze bottle. (I worked it out on a large sheet of inexpensive paper before transferring the design to the Arches.) After the acrylic dried, I saturated the paper on both sides, sponged off the excess water, and began painting the abstract shapes, paying no attention to the subject matter. After completing the abstract underpainting, I began finding the four dolls. The line drawing was done symmetrically, but the painting was asymmetrical, emphasizing the arbitrary shapes incorporated into the composition by the underpainting."

GEMINI, Patt Odom. *36" x 29" (91 cm x 74 cm), water media on D'Arches hot-pressed paper. Collection of the artist.*

"The inspiration for Gemini *came from a photograph of myself that lent itself to just such a double image.*

"I creased the paper in the middle, opened it, and wet it well on both halves. I then quickly drew the image on the left half of the paper with acrylic paints, folded the paper together, and pressed it hard to force the print onto the right side. After opening it, I accented the figure with calligraphy brushstrokes, and squeezed sepia ink onto the left side of the figure and painted a flat opaque ground behind the heads. After this dried, I painted the surrounding negative spaces with phthalo blue ink, allowing some of it to mingle into the lower half of the figure, where it was resisted by the acrylic paint."

Exploring Radial Symmetry and Kaleidoscopic Effects

CORAL CENTER. Photograph by Maxine Masterfield.

Radial symmetry abounds in nature, always drawing us into its center. One of mankind's most visually fascinating gadgets also plays with radial symmetry: the mirrored kaleidoscope. Paintings can be based on this kind of symmetry also.

KALEIDOSCOPE SERIES: DOORWAY, Joyce Bennink. *40" x 40" (102 cm x 102 cm), water media on Arches 140 lb. cold-pressed paper. Private collection.*

"This painting began during a day of hilarious adventure with a friend. The idea was born of making a painting out of a picture of a man's head used architecturally as the ornamentation over a door, his open mouth as the doorway. However, when drawn, it seemed empty and uninteresting. I then decided to draw the subject repeated four times, controlled and symmetrical—and the composition became much more exciting.

"I began with an acrylic drawing, then an underpainting of red-violets and blues. The rest was then painted in color by color, moving around the design until it was finished."

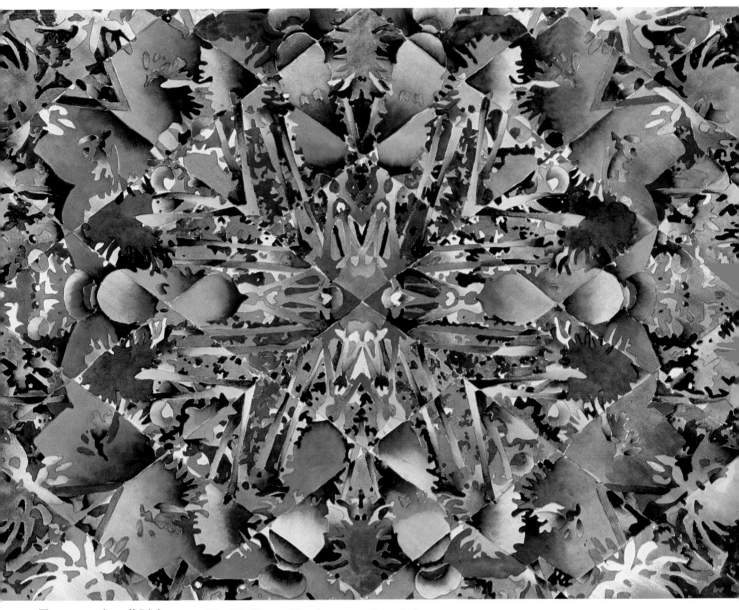

Thistles, Annell Livingston. *22" x 30" (56 cm x 76 cm), water media on Arches 140 lb. hot-pressed paper. Courtesy of Sol Del Rio Gallery, San Antonio, Texas.*

"This composition was based on formal balance, and I incorporated a diamond grid with the symmetry. The painting started with an original sketch of some thistles in Austin, Texas. A pie-shaped wedge was taken from the sketch, from which the composition was created. I found this was an exciting way to design because a slight shift in the placement of the original wedge created a totally different composition.

"First I established the grid, working warm against cool. Then I completed the painting by adjusting shapes to harmonize with the overall design."

Viewing Nature from New Perspectives

EMBERS, Tom Anderson. *40" x 60" (102 cm x 152 cm), mixed media on Crescent board. Collection of Barnett Bank of Southwest Florida.*

"Nature's complexity and ambiguity defy absolute understanding, and I find that particularly intriguing.

"In Embers I wanted to create the illusion of heat and light radiating from within the painting, similar to the feeling of looking into a campfire. I surrounded hot reds and yellows with cooler reds, violets, and purples. To increase the illusion of depth, I used torn magazine pages as masks to make hard-edged geometric planes, contrasting them with soft color bursts of the initial washes. I also used a cool gray colored pencil to detail some shapes in the center of the painting and white pencil to reinforce the geometric pattern of the silhouetted planes."

Fantasy is the purest and most honest form of visual creativity. When we paint fantasy, we can explain it or choose not to. We ourselves don't even have to understand it. Whereas reality demands, art allows. And where art follows fantasy, there is a vital feeling of disclosure, whether we can fathom it or not.

Experimental artists are constantly inventing new ways to present their impressions and versions of nature. Many have discovered that fantasy allows them to see nature from refreshing new viewpoints. For example, rather than painting a landscape as it actually appears to our eyes, we can imagine how it would appear from an airplane, and paint bird's-eye views with the kinds of intricate patterns that appear on topographical maps. We can delve far back into the past to create scenes reminiscent of ancient cities. Or we can travel to other planets and galaxies lightyears away to create mysterious images of outer space. After all, nature exists on the grandest scale we can imagine—as well as in the more familiar scale of mountains, trees, and oceans, and in the even smaller scale of crystals viewed under a microscope. No matter where we look, nature presents us with something to inspire us. And the gift of imagination lets us ride through time and distance as we choose.

If we stay in tune with nature's rhythms, our work will flow with those rhythms, helping us live up to our artistic goals. Conversely, painting our visions of nature will continually renew our love for it, and those who have learned to *live* in harmony with nature are well on their way to realizing their full potential as human beings, not just as artists.

It is crucial for mankind as a whole to learn more respect for nature. If our work inspires even a few people to care more about the world around us, then we have accomplished something very important—even though it may seem like just a small thing.

No matter how man may change the actual look of nature over time, its essence remains inviolable. It falls to us to define that essence and invent ways to portray it. The individuality of our awareness, what we each seek and find in nature, will determine our unique invented visions.

Viewing the World from Above

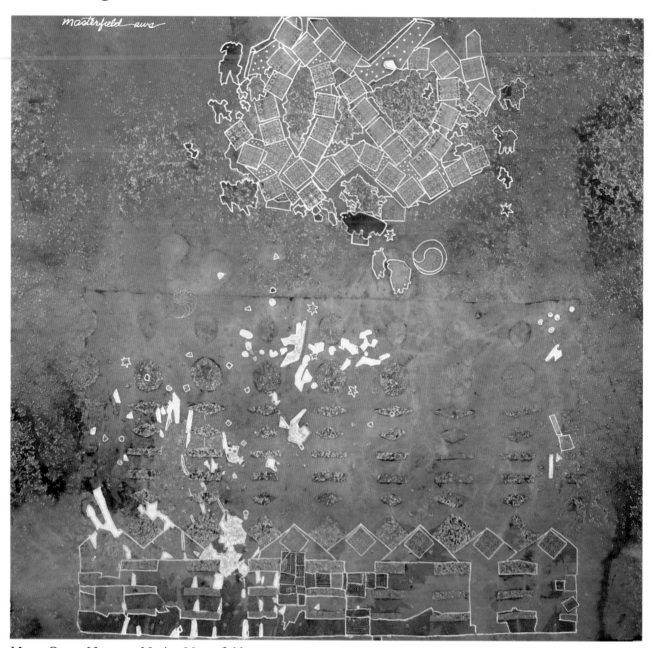

MOVE OVER, NATURE, Maxine Masterfield. *36" x 35½" (91 cm x 90 cm), inks on watercolor paper. Collection of the artist.*

Move Over, Nature *is a sort of bird's-eye view of where I live; it also tells the tale of man's encroachment on the wilds. I used pours and sprays of ink textured with resists, shells, and folded tissue cut-outs. The clustered condos are stamped with silver ink, and the shells indicate fossil pits. Even in the sea man is building structures of commerce and entertainment.*

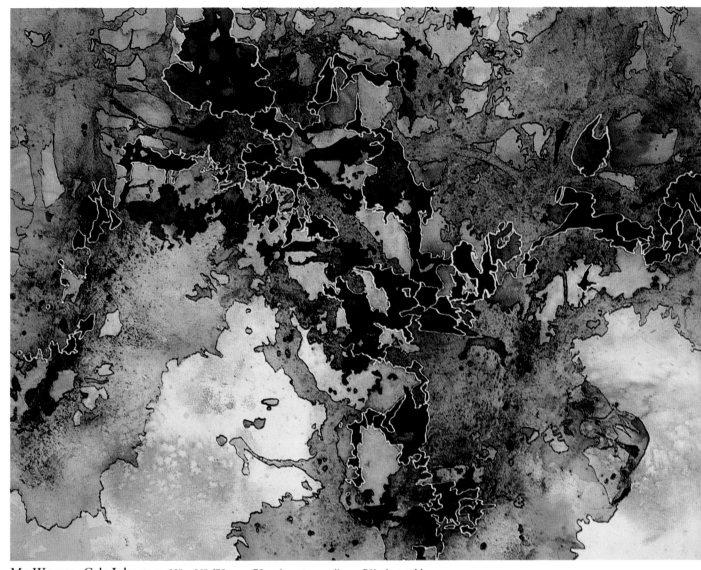

MY WORLD, Gale Johnston. *22" x 30" (56 cm x 76 cm), water media on D'Arches cold-pressed paper. Collection of Anglo American Insurance Company.*

"I've enjoyed experimenting with techniques in which I scatter dried materials on watercolor paper and then throw, sprinkle, or squirt water onto the paper. Each substance reacts differently.

"My World started with a watercolor wash. I added Margarita salt and let it dry, sprinkled powdered charcoal abstractly on the paper, and then threw water across the page.

"When the painting was dry, I knocked the excess charcoal off the paper and began to clean up areas or emphasize shapes with a kneaded eraser. It was at this point that the composition started to develop. Shapes began to suggest the terrain of the world surrounding me in my studio. I'm up high on my lot and can see and feel the trees and growth all around me, like being in a tree house in a thick forest.

"I felt that some calligraphy would bring some of the forms into sharper focus, so I added lines with white latex."

Exploring Ancient Worlds

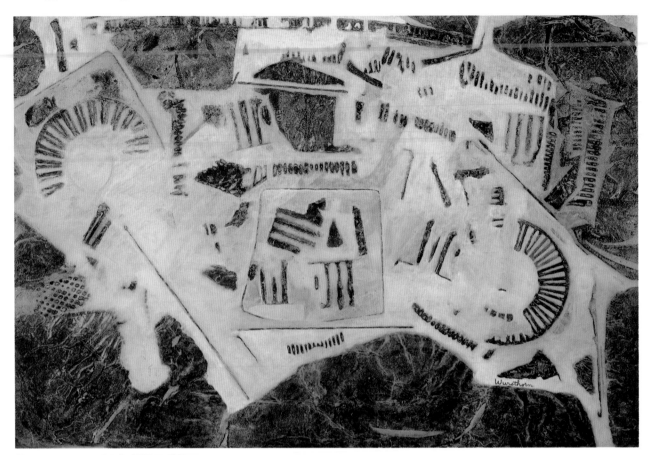

CHAPULTEPEC, Mabel Wursthorn. *27" x 37" (67 cm x 94 cm), water media on Arches cold-pressed paper. Private collection.*

"In a visit to Mexico, I was fascinated by all the Aztec designs used in pottery and carvings. The name of this painting, Chapultepec, *means grasshopper, and the area outside of Mexico City where many Aztec artifacts are found is named the same. Here the shapes and images work not only as symbols, but almost as a glimpse at an ancient culture, suggesting the history of the area and the traditions that are handed from one generation to the next.*

"I stretched my paper and stapled it to a board, then gave it two coats of gesso. In some areas I poured my watercolors and inks; in others I used a medicine dropper to apply a very small amount of a certain color. I then set shapes cut from waxed paper and plastic into the wet colors. Keeping the board flat, I continued adding color, water, and shapes until my composition was finished. Some background tones were worked in later with a moistened brush and diluted acrylics."

Finding Imaginary Worlds

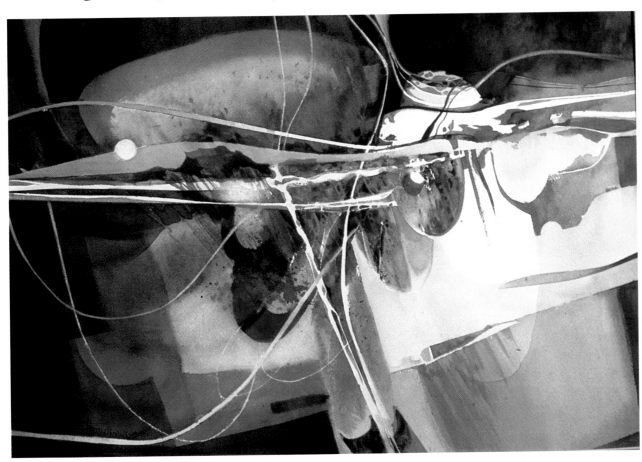

EMERGENCE, Marilyn Hughey Phillis. *15" x 22" (38 cm x 56 cm),
watercolors on Morilla paper. Private collection.*

*"Emergence is part of a series of paintings in which I
emphasized space. I am always looking beyond for the fuller
meaning of events, and for the mysteries that lie beyond our
world. I spent many childhood hours looking at the sky,
discovering images in clouds and in stars. How much the urban
child misses when the the sky is obstructed by buildings, lights,
and smog!*

*"Emergence was developed with numerous layers of glazing
to create subtleties of color and transitional shapes. Initially, I
blocked out certain structural forms with masking tape. I enjoy
spontaneous design and let it direct whatever else might come.
The choice of the dominating cool blues gave the immediate
feeling of atmosphere and outer space. As the lines swooped
through the painting like fleeting energy, bursts of warm color
became undulating areas of power at the points of greatest
activity."*

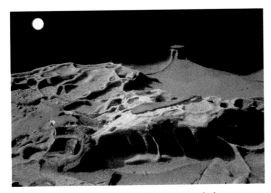

MOON OVER ATLANTIS. Photograph by
Howard F. Stirn.

*The photographer just couldn't resist
transforming this image of eroded rock into
something far more mysterious! When
copying the slide, he combined it with a
separate shot of the moon.*

135

Experimenting with Images of Outer Space

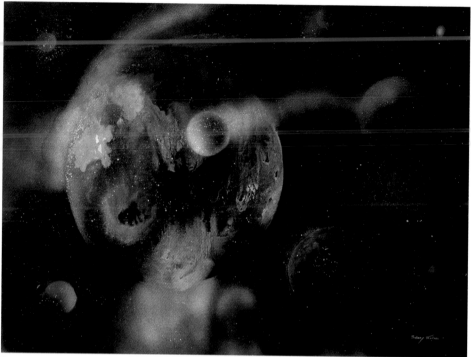

RADIANT GEOMETRY, Sidney Moxham. *30" x 40" (76 cm x 102 cm), water media on Crescent 114 lb. board. Collection of Mr. and Mrs. Robert Templin.*

"The not-quite-known gives free rein to one's imagination. Rather than becoming literal in my translation of the cosmos, I preferred to let invention take over and emotion finish the painting.

"I mixed acrylic paints with water to pour directly onto the board, letting the colors mingle. Then I cut out circles of different sizes and moved the empty circles around the board to see where they had the most exciting effect by surrounding the colors already there. Next I placed each corresponding paper circle over the right spot as a mask and sprayed a different color around each one until it was surrounded by dark space. After lightening and darkening the edges of the moons to give them roundness, I sprayed white to suggest trails, followed by color to soften the effect."

THE CREATIVE PROCESS, Walt Harmon. *21" x 29" (53 cm x 74 cm), water media on watercolor paper. Private collection.*

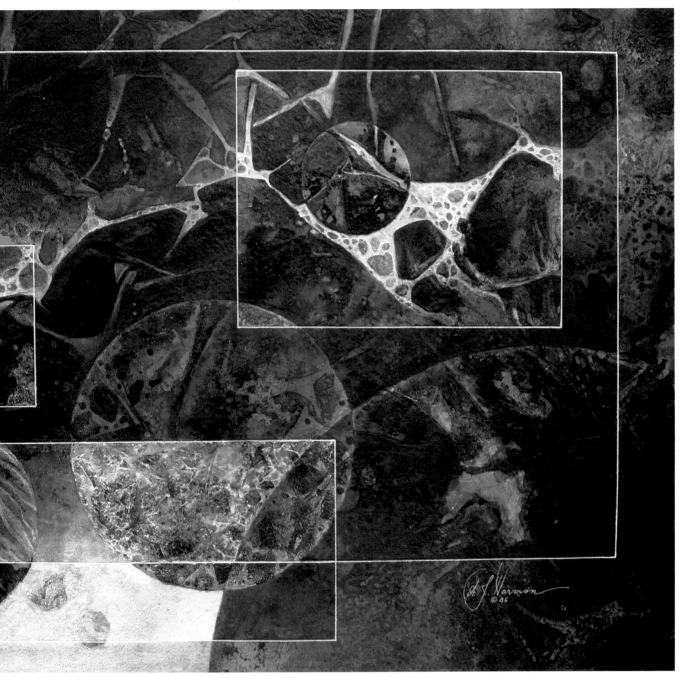

"My paintings often take on a futuristic, spacelike quality. But though the circular elements are often mistaken for planets or other celestial bodies, I really have very little interest in outer space per se. I am vitally interested in the organization—and orchestration—of color and space within my work. Like the circles, other geometric elements (rectangles and squares) are used as design features. The organic elements often suggest rocky forms, mountains, ravines, water—and yes, outer space.

"I use plastics and stencils for textures and shapes, striving for exaggerated contrasts of value, texture, color, and line. In every work I aim for a strong sense of drama, and intensity."

Using Light to Shape Objects in Space

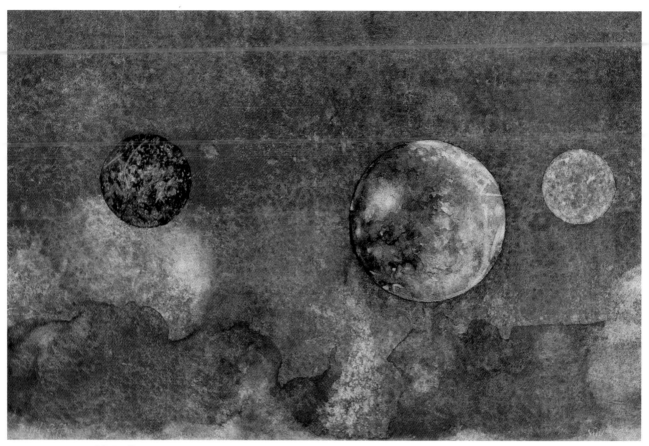

VISITANTS, David Coffin. *6" x 9" (15 cm x 23 cm), watercolors on hot-pressed board. Private collection.*

"I try to create a space in my paintings, like a stage, within which objects have a position and can act, but where the paint itself has the main role. start with carefully drawn and masked boundaries between objects. Then I start improvising, usually working from photo references of the effects of light that evoke space for me. When the space feels right, I unmask the actors and start giving them faces.

"I use graded, glazing washes with heavy mineral pigments like cobalt violet and ultramarine blue; color lifting works best with these nonstaining pigments. After years as a transparent purist, I've recently started to enjoy the flat, opaque, and decorative possibilities of gouache, in small doses."

Painting the Source of Light

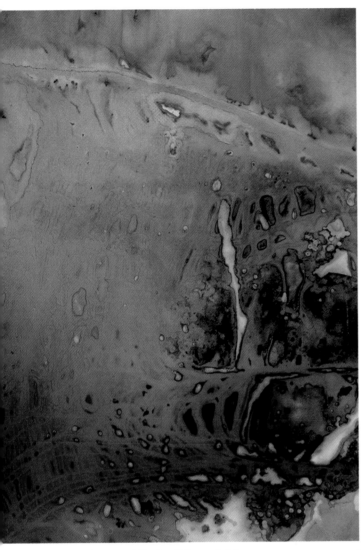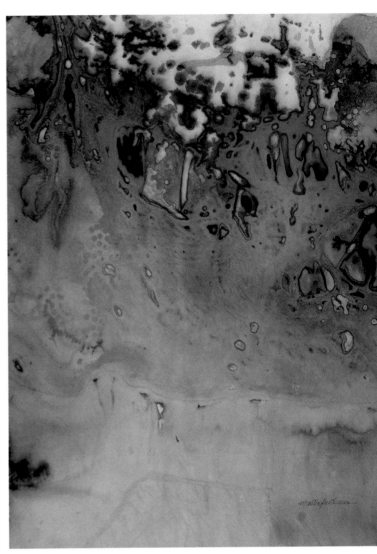

SOLAR FLARES, Maxine Masterfield. *Diptych, total size 40" x 52" (102 cm x 132 cm), inks on Japanese mulberry paper. Private collection.*

I had every right to see exploding sun flares in my painting, because it was created in bright sunlight.

I tried an experiment with fine absorbent paper, to see how much color it would pick up if I used it dry over fabric that had absorbed all the colored inks in a large tray. I placed two sheets of the fine paper side by side on top of the soaked fabric, which was lying in a large box. The color slowly bled through the paper, which acted like a blotter. I used no weights, so the paper flattened itself into the design of the fibers as it became damp with the inks.

Imagining New Worlds

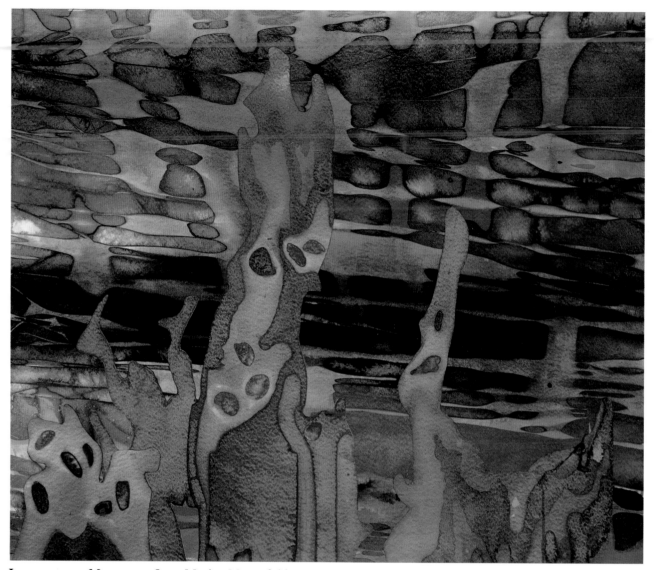

LAND OF THE MIDNIGHT SUN, Maxine Masterfield. *34" x 42" (86 cm x 107 cm), inks and collage on watercolor paper. Courtesy of The Alan Gallery, Berea, Ohio.*

I did not deliberately plan this painting, but I was pleased to discover that it illustrated a fantasy for me: a planet somewhere in another galaxy, whose atmosphere consists of waves of filmy color, and whose plants sway in rhythm to unearthly music that they create themselves. (Perhaps such a planet would be inhabited by creatures like those on the opposite page—who knows?)

To make this painting I poured large washes of ink across the surface of watercolor paper. Because the wet paper buckled, the color fell into the valleys, leaving only a light tint on the higher ridges but deeply staining the low areas. I then placed a heavy sheet of plastic over the painting to give contact to the raised areas it touched. The inks dried overnight. I actually did two paintings this way, and cut out and collaged shapes from one painting onto the other for Land of the Midnight Sun.

THE JOY OF FANTASY, Charles Kapity. *16" x 14" (41 cm x 36 cm), watercolors and acrylic on Rives BFK paper. Private collection.*

"I usually have a thought in my head of what I'm going to paint, but not a complete picture. This is why my paintings are such a process of surprises, with each shape forming into some "thing" as I go along. This particular piece is a prime example of that kind of evolution of brushstrokes into recognizable (and not-so-recognizable) elements.

"I poured the background using unraveled cheesecloth and inks. The curving line texture from the fabric pour was the inspiration for my creatures all being so linear and concentric. I worked along with this mode until it blossomed out. In this work I happened to start from the center and painted myself out and down using watercolor and acrylic."

List of Suppliers

Many of the supplies you will need to create paintings like those in this book are available in any good store that sells art or craft supplies. (For example, you should have no trouble finding Morilla watercolor paper or colored crayons.)

Some more unusual items are easier to order directly from the manufacturers. Here are a few sources that you may find helpful.

To Order:	Contact:
Air mist bottles	JAS International 2033 W. Warner Ave. Chicago, IL 60818 (312) 472-8291
Artcor boards	Fomebords Co. 2211 N. Elston Ave. Chicago, IL 60614 (800) 362-6267
FW colored inks, Luma watercolors	Daler-Rowney USA 4 Corporate Drive Cranbury, NJ 08512-9584 (609) 655-5252 Daler-Rowney USA will be pleased to notify you of a local supplier
Hot wax batik tools, Dippity Dye paper	Dick Blick catalog P.O. Box 1267 Galesburg, IL 61401 (800) 447-8192
Movable easels	MobilEasel 2302 NE 145th St. Seattle, WA 98155 (206) 367-1272
Pipettes	Poly-Med Inc. 2009 Green St. Hollywood, FL 33020

Acknowledgments

I would like to express my appreciation to all the artists who contributed their ideas and work to this book, and to Mary Hudak, who helped me find the words to express it all.

Special thanks go to Jay Anning for his design, and to Candace Raney, Marian Appellof, and Janet Frick for editing my material.

I am also indebted to Nancy and Gerald Gable and their family for assisting me in so many ways, including Gerald's excellent photography of my work. And I am especially grateful to my husband, George, who is always by my side. Thank you.

Index